Also by Bridget Beth Collins

Flora Forager: A Seasonal Journal
Collected from Nature

THE ART OF
flora
FORAGER

Bridget Beth Collins

SASQUATCH BOOKS
SEATTLE

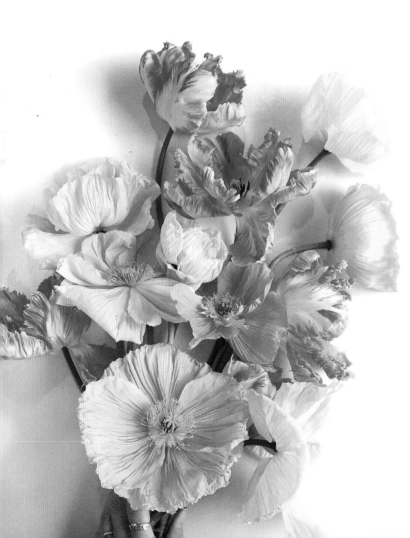

Printed in China

Published by Sasquatch Books

21 20 19 18 17 9 8 7 6 5 4 3 2 1

Editor: Hannah Elnan
Production editor: Emma Reh
Design: Bryce de Flamand

ISBN: 978-1-63217-150-4

Sasquatch Books
1904 Third Avenue, Suite 710
Seattle, WA 98101
(206) 467-4300
www.sasquatchbooks.com
custserv@sasquatchbooks.com

This book is dedicated to those who tend our garden planet in the shade of opposition. May my great-great-grandchildren dance in meadows and walk through forests from the seeds you have planted with hopes for light.

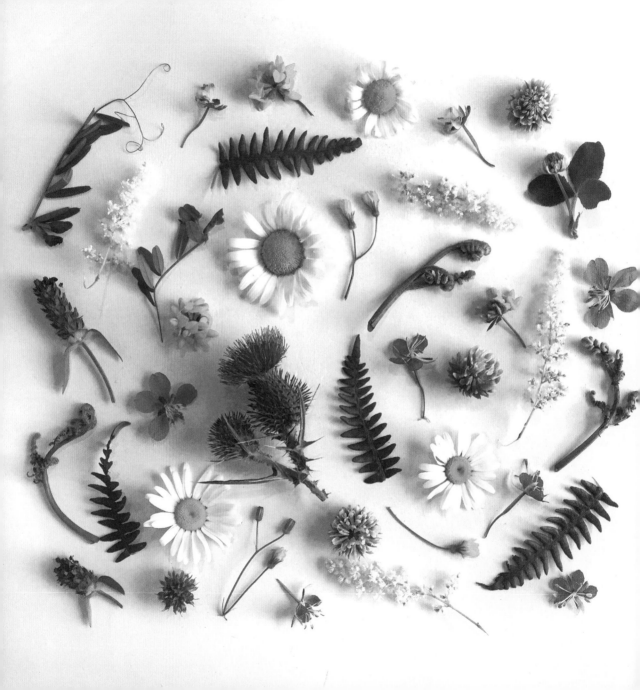

Contents

Introduction *8*

Memories & Muses *10*
Mandalas *54*
Master Copies *68*
Fantasy *80*
Iconic Women *94*
Animals *110*
Birds *122*
Insects *132*
Sea Life *142*
Bits & Bobs *150*
For My Boys *158*

Acknowledgments *167*
About the Artist *168*
A Peek at My Process *170*
Index *172*

Introduction

Petals trailing from the fingers of a flower girl, a bouquet thrust into the arms of an actress, or sprigs placed gently on a grave: flowers have meaning in almost every culture, religion, and social tradition. In Sweden girls put seven flowers under their pillows with hopes of dreaming of their future loves; in Japan lanterns and festivals welcome the cherry blossoms. In Croatia it is said that the god Perun struck his lightning on the land and *perunika* (irises) first grew. Marigolds are strung for the Day of the Dead in Mexico, poppies are worn for fallen soldiers in England, and fern swirls are tattooed on the Maori people in New Zealand.

Flowers evoke an emotion in the human spirit that I can't seem to find in any other medium. How better to evoke a scent memory of years past? To say we love or mourn or are sorry . . . without having to say anything at all? Flowers are a child's first gift, grasped in chubby fingers, for their mother. They are crowns for pretend princesses, and the most luxurious riches you can pluck for free. They are a reminder that nothing is truly lost in the wintry seasons of our lives, for year after year they return to us, reaching for the light. And, in turn, they teach us to look up too.

My desire with Flora Forager has always been to show the magic of nature. I want to weave spells made of flower petals, pinecones, and mushrooms; show flowers growing in unlikely places; surprise and delight with unique colors, patterns, and frills. In a world of sorrow, darkness, and the unknown, flowers are always there for those seeking beauty, light, and comfort. Their magic comes surprisingly, delicately, and freely. And I want to share it with you.

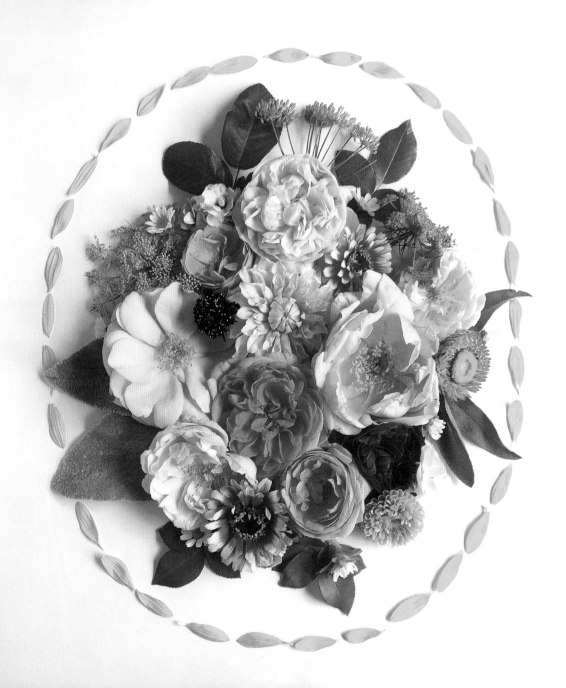

MEMORIES & MUSES

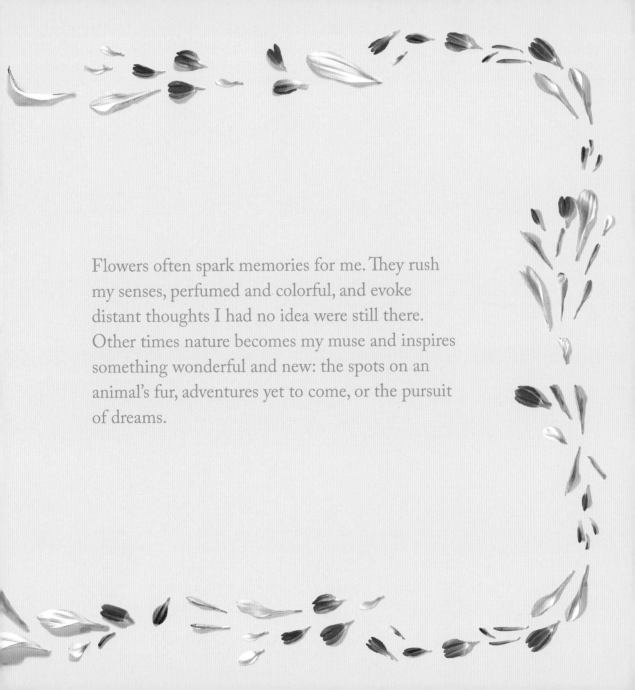

Flowers often spark memories for me. They rush my senses, perfumed and colorful, and evoke distant thoughts I had no idea were still there. Other times nature becomes my muse and inspires something wonderful and new: the spots on an animal's fur, adventures yet to come, or the pursuit of dreams.

Home Sweet Home

Cherry leaf, daisy, gerber daisy, narcissus, pansy, primrose, waxflower

When my husband, Beau, and I were looking for a house, I told him I would love a round door. We searched and searched for the perfect place to call our own, and one day Beau found it: a little urban cottage with a round red door. Beau named it The Burrow, and it's been home ever since. Now that time has passed, it isn't the door that really matters, it's the memory that Beau cared. It's little things like that that make Beau my real home. And these blue primroses line the path to my round door!

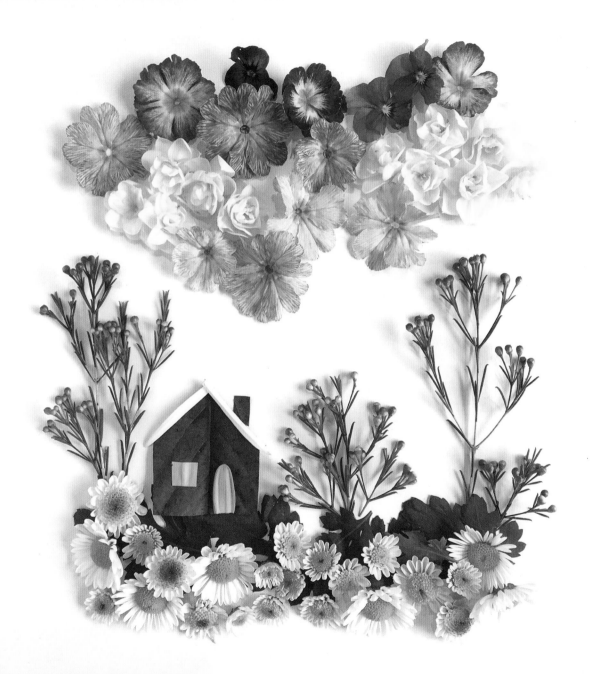

Surfers

Chrysanthemum, dahlia, dusty miller, hen and chicks, hydrangea

I lived in California for three years when I was very young. The thing I remember best is the trees. My mother tells me I was so obsessed with trees I would say "tree!" every time I saw one. My earliest memory is sitting under a large orange tree in our back garden, the light streaming through the leaves. Succulents take me back to those palm-filled days, and here they make a perfect landscape for a foamy coast.

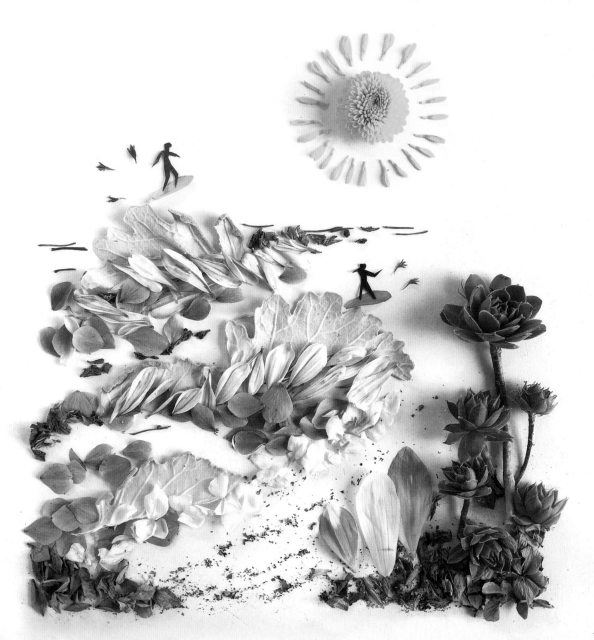

Plane

Carnation, chrysanthemum, dahlia, zinnia

One of my favorite books is *A Severe Mercy*. There's a part where Davy and Van are in Van's small plane flying through rosy clouds. When he dips the nose of the plane, lilac flowers fly back toward him from the bouquet Davy is holding. "So we played in the sky in that beautiful and splendid Maytime dawn. Flight in lilac time."

Woodland Birthday

Begonia, bellflower, firethorn berry, fly agaric mushroom, Japanese maple, pinecone, rose, rose hip, woodland mushrooms

When you find mushrooms growing in a circle, they are called a fairy ring. It means the fairies have been reveling and left their chairs! Every fall I take my kids into the woods to hunt for the brightest, largest, most interesting mushrooms we can find. Our favorite is fly agaric, the poisonous, but beautiful red ones with white spots.

Volcano

Black maple leaf, blanketflower, cedar, chrysanthemum, grass, oak, weigela leaf

My blanketflower always reminds me of fire. Their red and yellow colors and jagged edges look just like flames. When I was little, I thought I might be able to go inside of a volcano and look around. I still wish I could!

Flamingos

Camellia, dahlia, eucalyptus, hydrangea, iris, marsh rosemary, royal grevillea

These shrimp-colored grevillea blossoms reminded me of flamingo legs when I saw them on their tree. I was so happy to find the perfect colors to go with them: the purple and sage of the waves complement the peach and pink of the birds. When I find something that works so well, it gives me a little thrill.

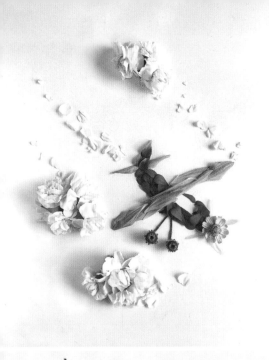

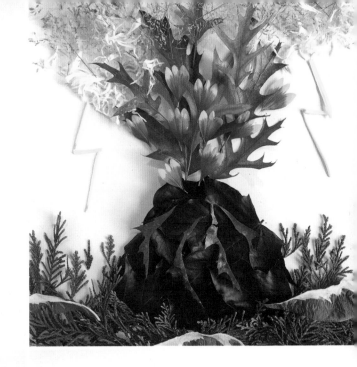

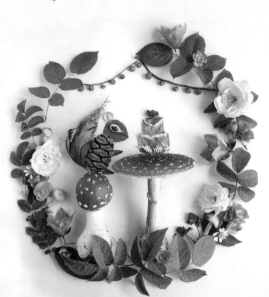

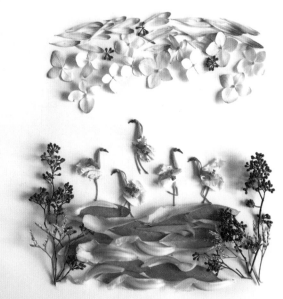

Hot Air Balloons

Cornflower, everlasting, feverfew, grass, iris, mallow, rhododendron, sunflower, tiger fig

One fall our family camped out in the desert and woke up to see hot air balloons floating in the pink sunrise. I held my baby Oliver, and we watched wide-eyed as those happy orbs took flight. My heart felt like it was soaring with them. When I discovered these figs at the market, they had much the same effect!

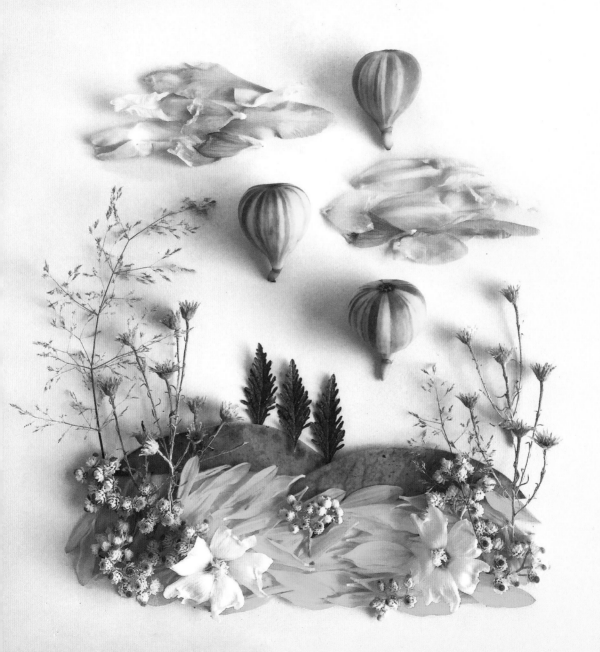

Green Gables

Beautyberries, birch, chrysanthemum, grass, lamb's ears, mallow seeds, pinecone, red maple, rose leaf, St. John's wort, strawberry tree, strawflower

My favorite female heroine is Anne Shirley, the main character in *Anne of Green Gables*. She taught me to pursue beauty and speak from my heart. And that those two actions are interconnected. In a perfect world we'd each have our own "Green Gables," a place where we are loved dearly and we can drink flowers in.

"I'm so glad I live in a world where there are Octobers."
—L. M. MONTGOMERY

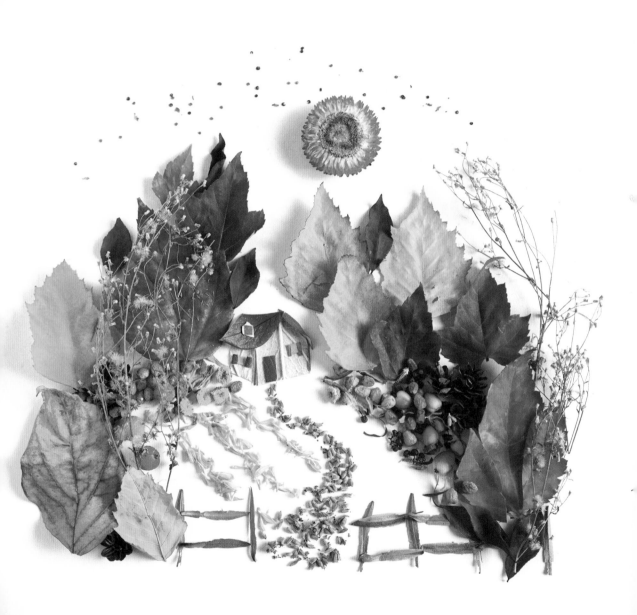

Anne of Green Gables

Daisy, fern, heather, Japanese meadowsweet, lacecap hydrangea, Peruvian lily, porcelainberry

I love the way Anne sees the world: her love of flowers and sunsets, silvery seas and bosom friends. I want to emulate all her bubbling exuberance for our dear old world.

"It is wonderful what flowers can accomplish if you give them a fair chance."

—L. M. MONTGOMERY

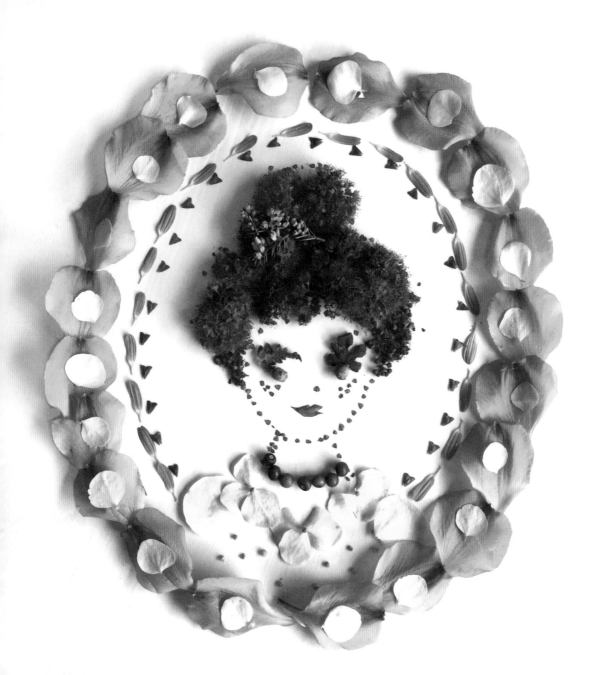

Sailor's Valentine

Black maple leaf, butterfly bush, currant, honesty,
honesty pods, hydrangea, mallow, maple leaves

During Victorian times sailors found seashells on
their adventures to make designs for their loves
back home. I wanted to make a floral one! When
I saw these pearlescent currants at the market, I
knew they would be perfect for pearls. I found the
rest in my garden: honesty for capiz shells, mallow
for scallops, and maple for a mosaic of gold. My
hydrangeas turned aqua that summer and were
perfect for water!

Shooting Stars

Cedar, hosta, hydrangea, jasmine, juniper berry

When my son Oliver was a baby I took him with
me to look for meteors. He had just had clubfoot
surgery and wore a large brace on his feet, but
I wrapped him up as cozy as I could and we
watched for the heavens to fall. Oliver fell asleep
against my chest while I kept looking up, thinking
he was as much a star to me as the ones twinkling
across the sky.

Night

Aster, baby's breath, dusty miller, honesty, rice flower,
thundercloud plum leaf

I wanted to create a stark contrast for a night
scene using only foliage. Here, thundercloud plum
leaves became a fitting night sky. That's exactly
what these trees look like: dark thunderclouds
raining pink blossoms in spring.

Eiffel Tower

Camellia, daisy

I first went to Paris when I was twenty. I was
dazzled by the lights of the Eiffel Tower and the
carousels at night, the profusion of pink, coiffed
trees and dainty filigree at every turn. There began
a lifelong addiction to flaky pastries and flower
stalls—and the desire for everything to be just a
little more pink!

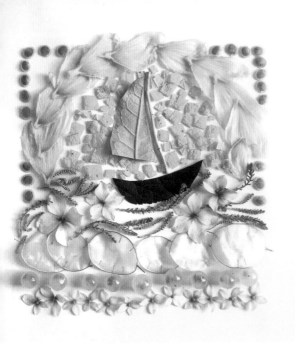

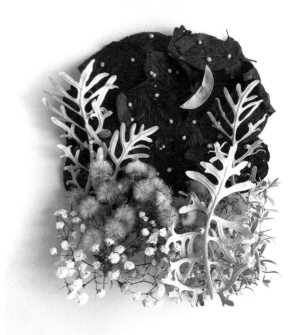

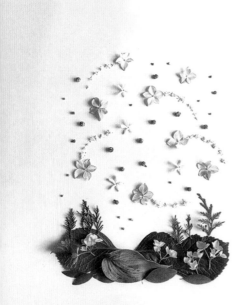

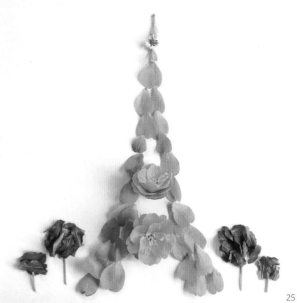

Flora

Aster, cedar, Chinese lantern plant, dusty miller, fern, honesty, lavender, pansy, pine, rose, seedpod, sunflower, yarrow

When my boys were babies, I wrote them a story about a little girl who forages in the woods. Her name is Flora. When I started making floral art, I named it after her! I hope one day the world will get to meet her too.

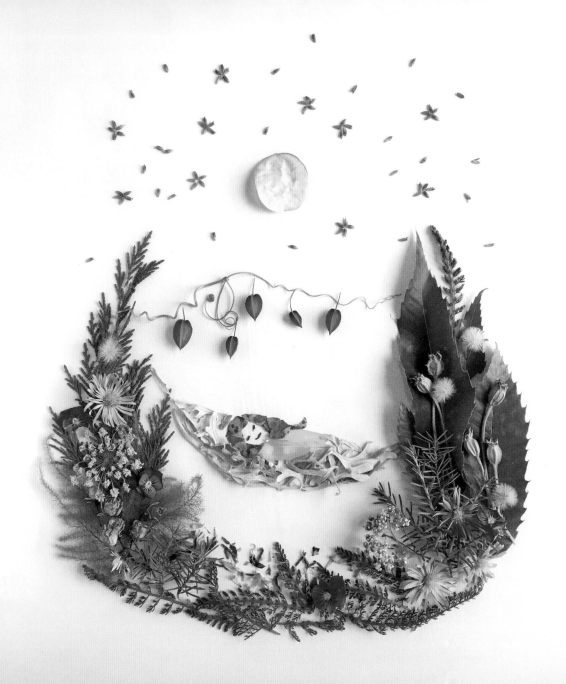

Safari

Blanketflower, butterfly bush, cedar, dahlia, dandelion, grass, phlox, rhododendron, strawflower, sunflower

It's one of my dreams to visit Kenya and go on a safari. I imagine sitting at the edge of my tent looking out at a shimmering mirage horizon, animals passing by in the heat. The next best thing is my imagination, and it is easiest to do so at the height of summer, when all the plants turn to gold. My rhododendron leaves occasionally turn a rusty, spotted yellow and every time it happens they remind me of giraffes!

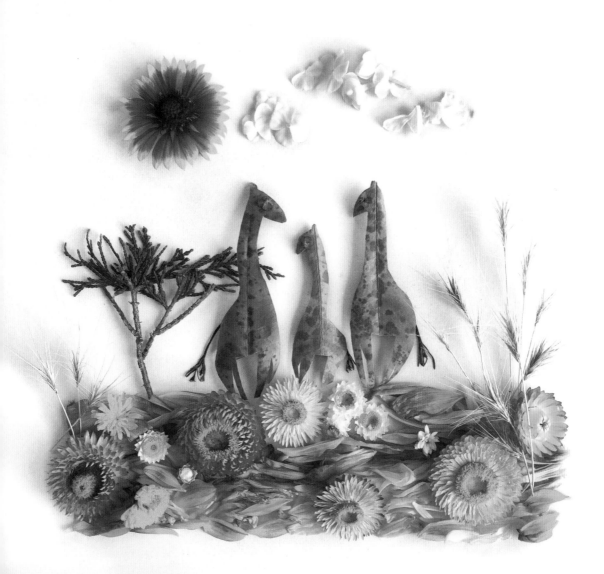

Koi

Dahlia, geranium leaf, maple leaf

I love going to the Seattle Japanese Garden in fall to see the turning leaves and feed the koi with my little boys. One time I was walking through falling leaves just outside the garden, and it occurred to me how similar the leaves were to the brightly colored koi. I felt like I was swimming through the pond.

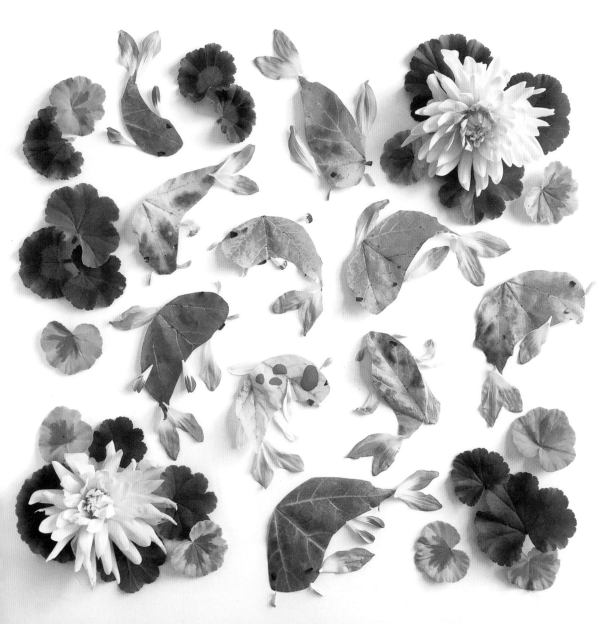

Geisha

Anemone, black elder leaf, bluebell, forget-me-not, French lilac, lilac, pansy, primrose, tulip

I was lucky enough to get to travel to the Miyako Odori, the annual geisha performance in the Gion district of Kyoto. My favorite dance was one where huge swaths of wisteria hung down among the geishas who were portraying spirits. I tried to recreate the look when I got home with bluebells and lilac blossoms from my garden.

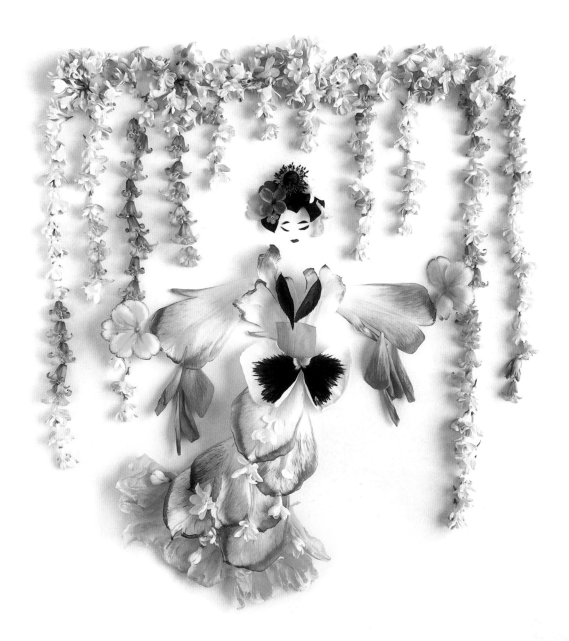

Kites

Alder, begonia, blanketflower, hydrangea, lavender, lilac, pumpkin vine, rose, sunflower

I was inspired by a kite festival on the Washington coast for this piece. I tried to find as many different colors as I could in my garden for the kites and used lavender stems for the strings. The "dune grass" blowing in the breeze at the bottom of the piece is a ruffly kind of silver lavender . . . my favorite.

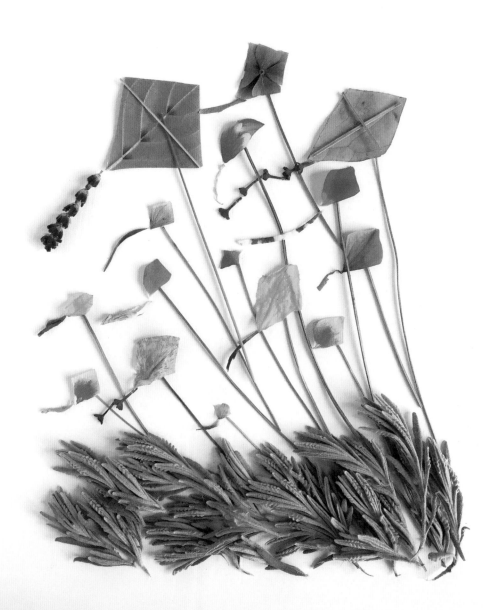

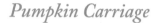

Pumpkin Carriage

Cyclamen, daisy bush leaf, geranium, lemon verbena, mallow, privet, pumpkin on a stick, pumpkin vine and leaf, sunflower

Pumpkin patches always remind me of the carriage that Cinderella's fairy godmother magically transformed for her. These little pumpkins are actually a type of tiny eggplant! The leaves are from a Cinderella pumpkin vine my boys grew in our garden. They were thrilled when their seeds sprouted and kept growing and growing. Plants have their own transformative magic. Bibbidi-bobbidi-boo!

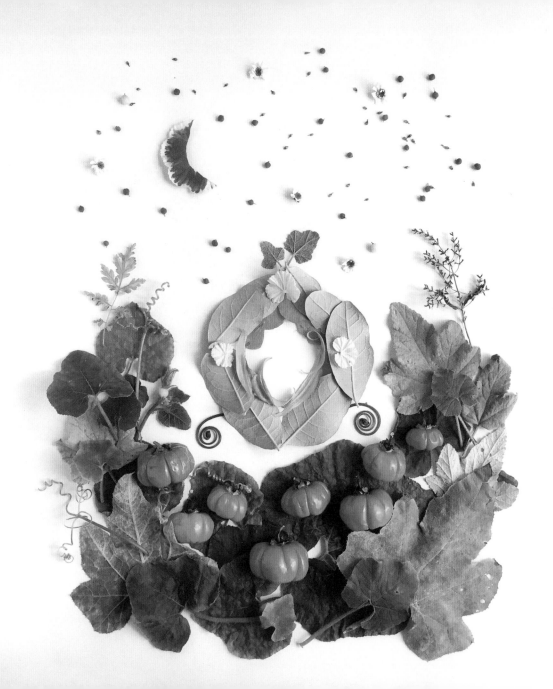

Sugar Skull

Camellia, dahlia, daisy, downy sunflower, firethorn berry, gooseneck loosestrife, hydrangea, laurustinus, rose, seaberry, snowberry, strawberry tree, yarrow

In Mexico ancestors are celebrated on the Day of the Dead by decorating graves with marigolds and painting sugar skulls with flowers. I think it's a beautiful tradition, so I created this skull out of live flowers for Halloween. I've found that a lot of people have a hard time when confronted with death, even though it is a natural, inevitable part of life, so I try to normalize and beautify it in small ways.

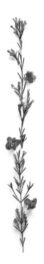

Sugarplum Fairies

Pink: Bitter cherry, carnation, cedar, dandelion, orchid, sea glass
Green: Carnation, cedar, hydrangea, lichen, sea glass
Purple: Carnation, dusty miller, eucalyptus, hydrangea, rose, St. John's wort

I love pink and sequins and girly things. I kept hoping for a little girl to dress up in ruby slippers and tutus, but I got three boys! So my little girls are the ones I make up out of flowers. These three sugarplum fairies were inspired by *The Nutcracker*. I listen to it every Christmas, and it makes my heart dance!

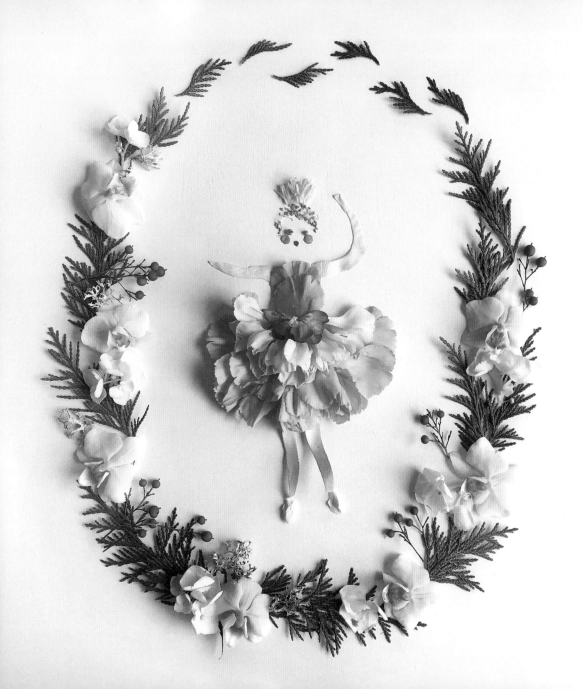

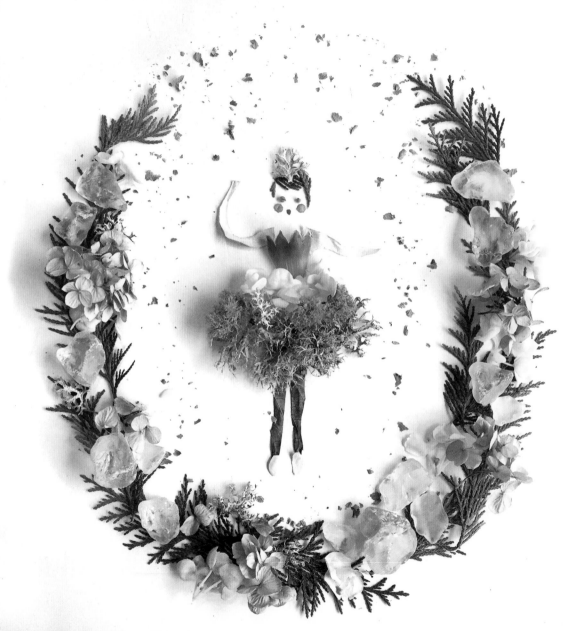

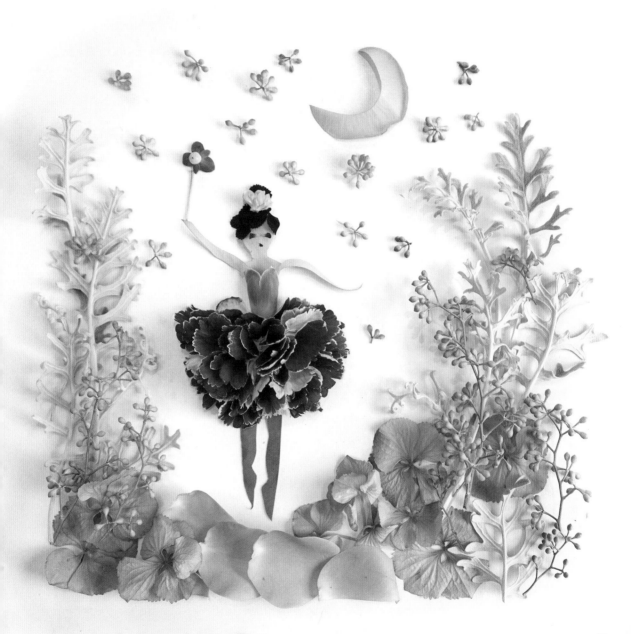

Winter

Baby's breath, chrysanthemum, dahlia, honesty, lily, silver poplar, spruce, sunflower

When I was little my family would spend a weekend every winter in an A-frame cabin in the mountains and ski onto a blanket of white right from our doorstep. I loved sleeping in the loft and watching the snow fall softly through the window. Now we continue the tradition by going to my sister's river cabin. We make hot chocolate, the boys play in the snow, and my sister and I watch mysteries. I love coziness. The best way I can describe this scene is *hygge*. It's a Danish word that means making ordinary moments special, cozy, and homey.

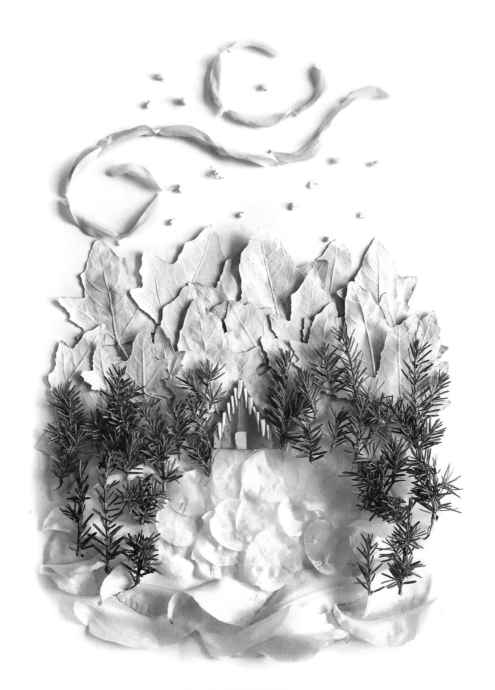

Spring

Black elder, Canadian horseweed, dahlia bud, dill, grass, hydrangea, lemon verbena, nasturtium, phlox

Spring never comes soon enough for me. I wait with bated breath for the first crocus buds and flush of pink in the cherry trees. I jaunt down to the lake to see if the water lilies have risen from the deep. Often I am disappointed. Nothing is as ready as I am to rise from the slumber of winter! For this piece I used nasturtium leaves for lily pads and dahlia buds for lotuses. It was a fun challenge to find something small to take their place in a miniature pond.

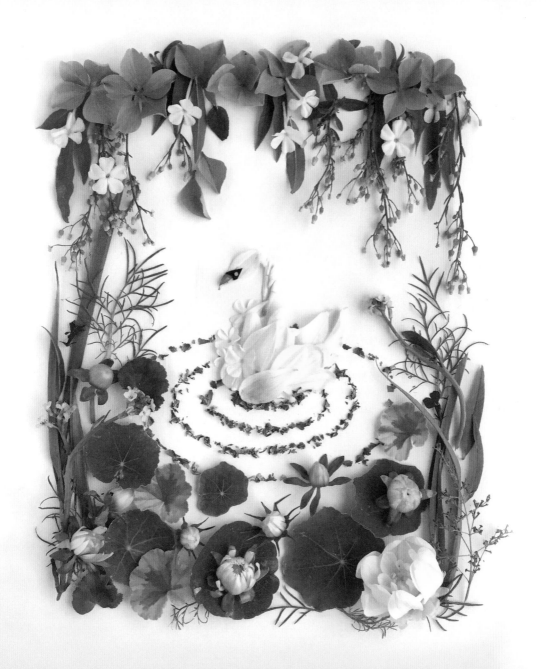

Summer

Boxwood, daisy, lavender, moss, poppy, rose, sunflower

Every summer I adventure to the Olympic Peninsula and make a stop at the lavender festival. Butterflies and bees flit through the rows of lavender; sunflowers and poppies line the edges; and I imagine I'm in Provence. I've planted a few varieties of lavender in my garden, and I love their delicious herbal scent and floral addition to culinary confections. My favorite? Honey-lavender ice cream!

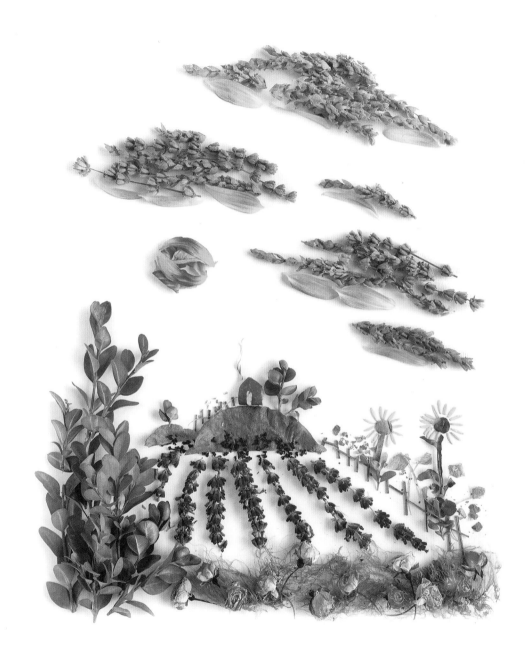

Autumn

Cedar, columbine, daisy mum, desert seedpod, hollyhock, maple, pineapple weed, sunflower

In autumn the world adorns herself with golden topaz and ruby jewels, glittering and shifting and dripping to the ground. The trees sway on a red carpet, wearing lavish frocks. It's the show of the season, a last banquet awarding their work throughout the year. Flowers in spring, fruit in summer, and now their confetti seeds floating into the air. Mushroom trophies rise up at their feet, birds fly in formation to the south, and I look up in wonder at their magic encore: beautiful and timeless, year after year.

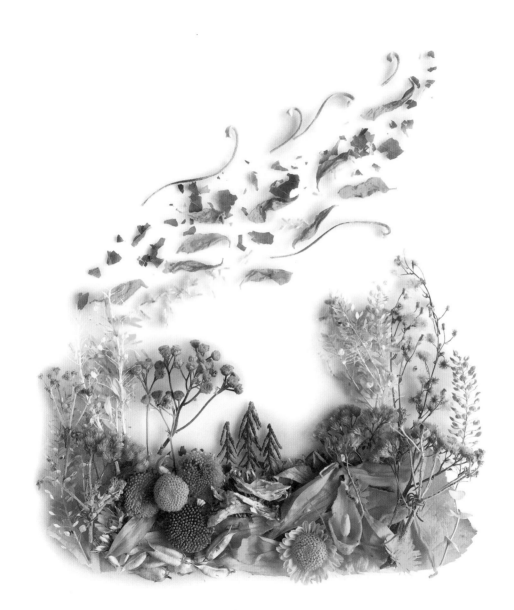

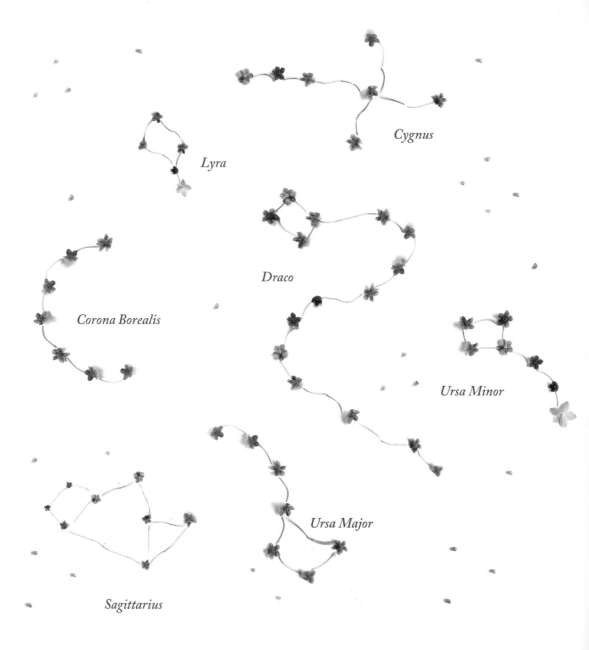

Cygnus

Lyra

Draco

Corona Borealis

Ursa Minor

Ursa Major

Sagittarius

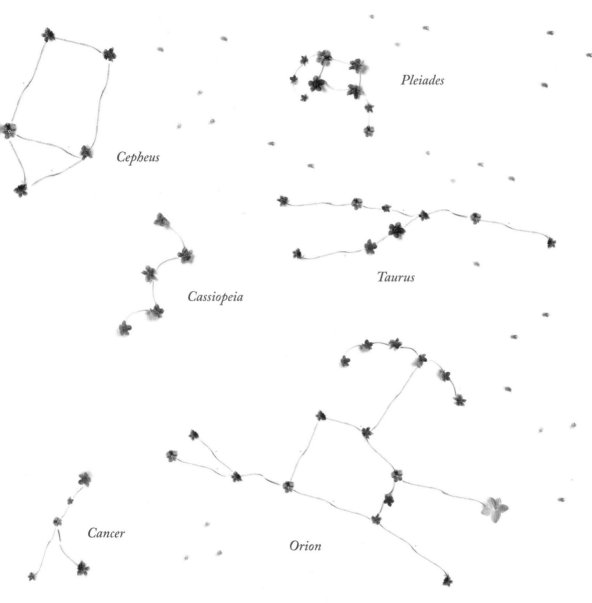

Cepheus

Pleiades

Cassiopeia

Taurus

Cancer

Orion

Constellations

MANDALAS

Whether used for religious purposes, offerings, relaxation, or a creative way to take a closer look at the natural world, mandalas give us beauty in cyclical form. For me mandalas are the representation of beauty radiating from my center, my heart, my mind, my soul. As I make flower mandalas, I am calmed and delighted, repeating color and form over and over in a mantra of petals.

During the summer I like to forage my materials from the outdoors and make a mandala to commemorate the adventure. After I finish the mandala, I take a photograph, then blow the petals away. Each moment is ephemeral, and I like the act of remembering that though beauty is fleeting, it can still be experienced lavishly.

MATERIALS

Blanketflower, dandelion, hydrangea, maple samara, mushroom (p. 57)

Bluebell, cherry blossom, rhododendron, rosemary, seaberry, tulip (p. 58)

Acorn, alder, camellia bud, fern, mushroom, rose (p. 59)

Butterfly bush, chocolate sunflower, hydrangea, mallow, poppy, tulip (p. 60)

Aster, beautyberry, inch plant, mimosa (p. 61)

Geranium, hen and chicks (p. 62)

Azalea, forget-me-not, golden wattle, pansy, rhododendron (p. 63)

Chocolate cosmo, rose (p. 64)

Dogwood, fir, foxglove, honesty, maple, rose (p. 65)

Dahlia, St. John's wort (p. 66)

Cherry blossom, chestnut flower, daisy, poppy, primrose (p. 67)

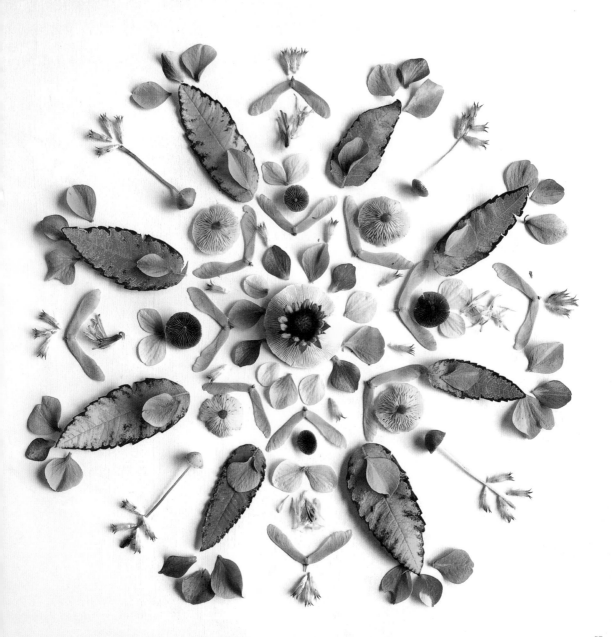

57

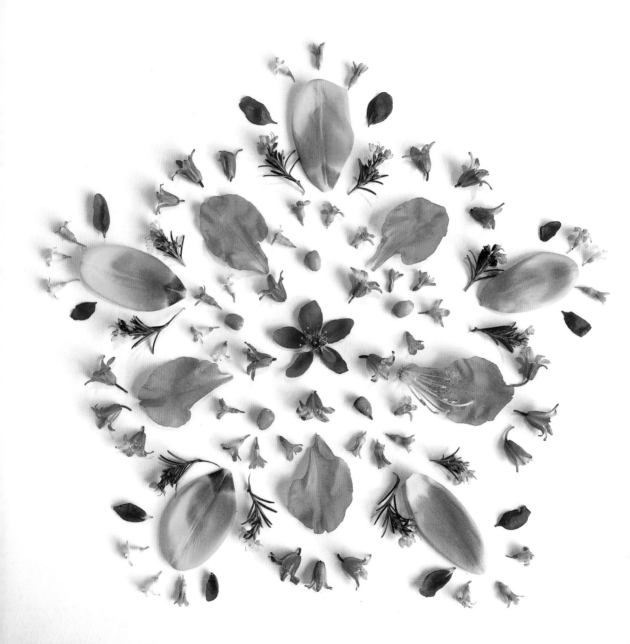

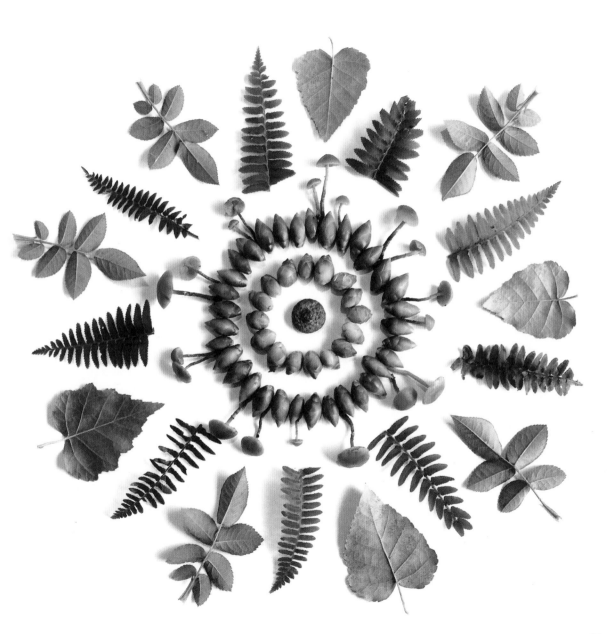

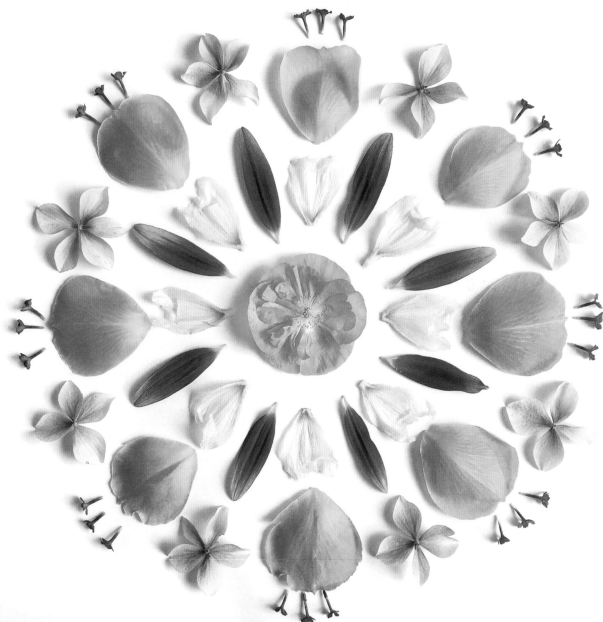

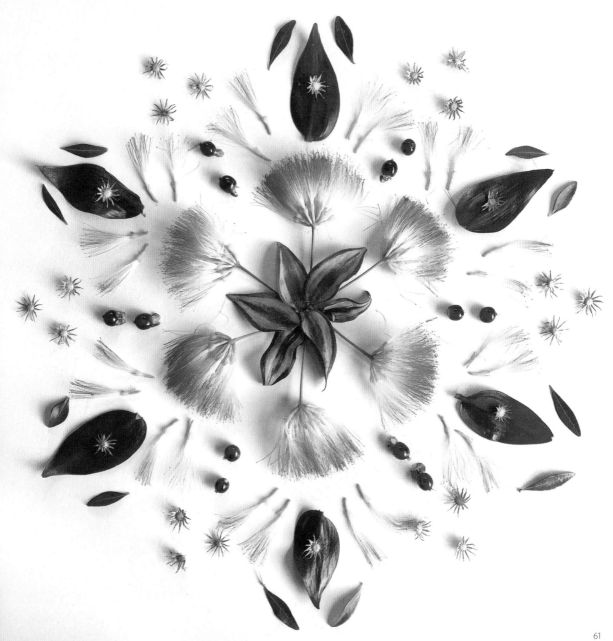

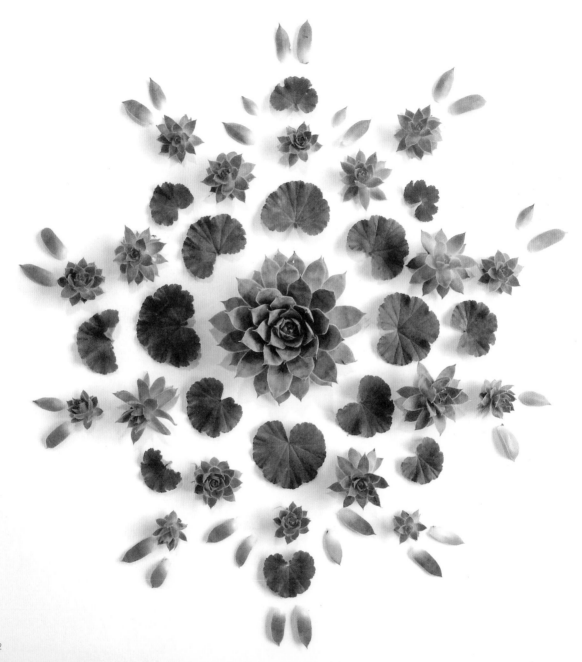

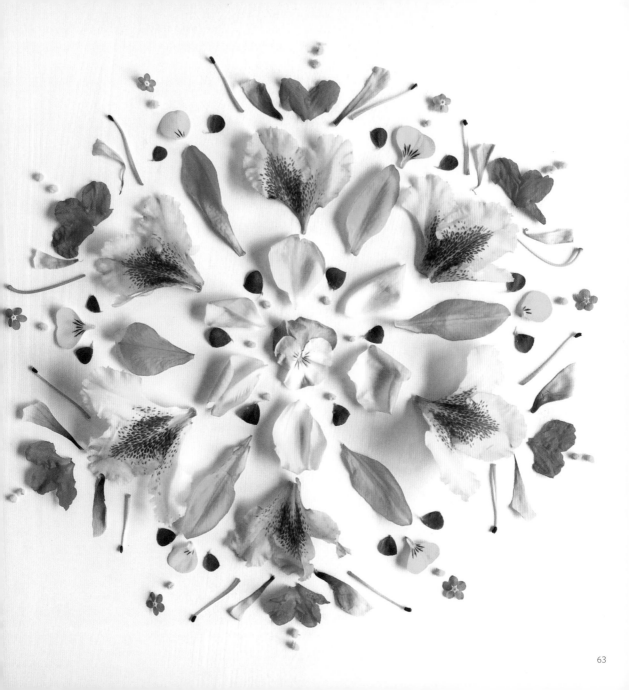

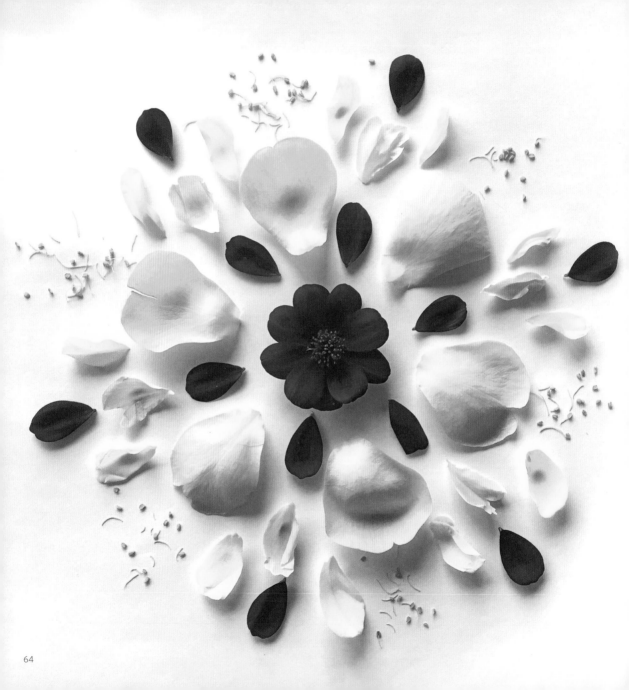

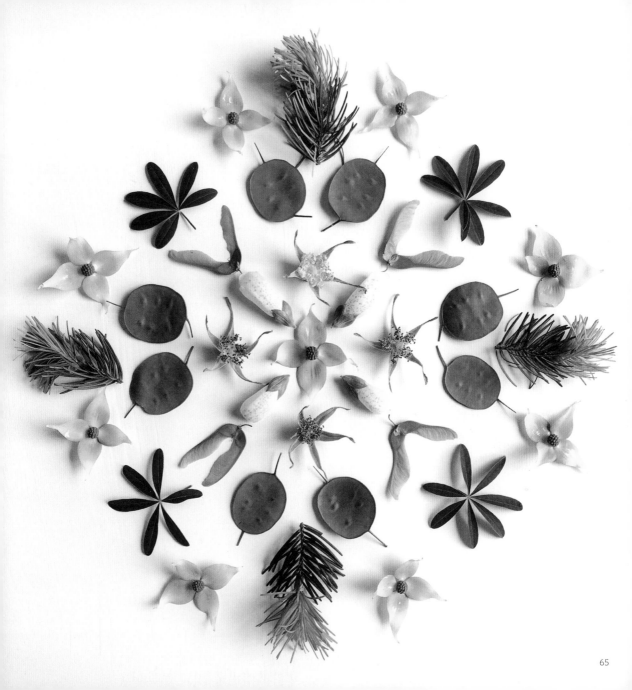

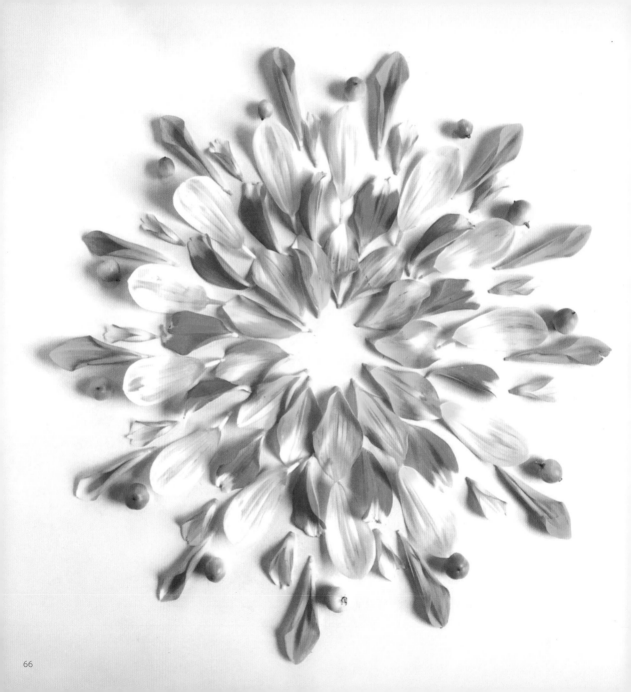

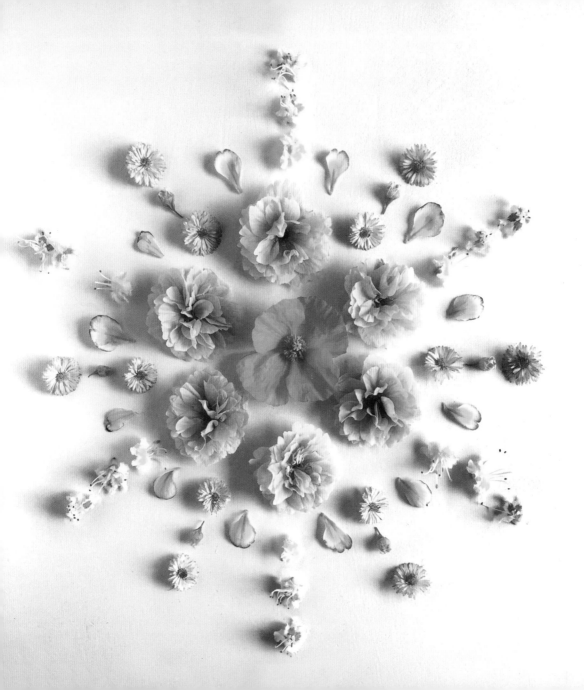

MASTER COPIES

When you learn to paint, you copy the brush
strokes of those who have gone before you.
You learn how to create emotions by copying
other artists' colors; you find out if you like
impressionism or modernism or realism by putting
yourself in other artists' shoes. When I started
creating art with flowers, I found that there was
nothing to compare it to. There were no brushes or
paint colors. Only petals and whatever colors there
happened to be in my garden. But I knew the kind
of art that I loved, so I set out to try to re-create
different pieces from the masters. Inevitably they
all got their own floral filter.

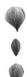

van Gogh's The Starry Night

Billy buttons, blueberry, chrysanthemum, hydrangea, lavender, sunflower

One of the greatest consolations I have as an artist is that van Gogh never sold a painting in his lifetime. Can you imagine a world without *Starry Night*? Perhaps one day someone won't be able to imagine a world without *you*.

Original: The Starry Night *by Vincent van Gogh (Dutch, 1853–1890), 1889. Oil on canvas, 29 inches x 36.25 inches.*

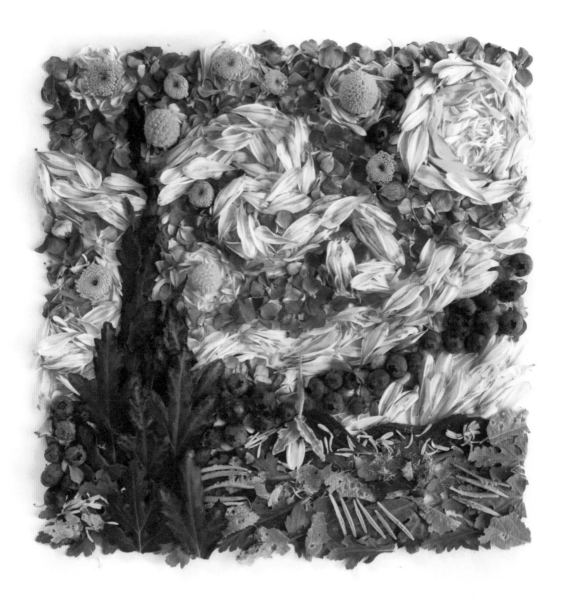

Klimt's Mother and Child

Aster, chrysanthemum, dahlia, daisy, lacecap hydrangea, lilac, pansy, Peruvian lily, pumpkin vine, sunflower

When I visited the Belvedere palace in Vienna, where many of Gustav Klimt's paintings are hung, I was awestruck by his elaborate gold leaf "mosaic" style, and especially his garden pieces. The garden outside the palace was littered with little yellow flowers while I was there, just like the golden flecks in one of the master's paintings. I felt like I had walked into one of his glittering works! This mother and child are a part of a larger piece called *The Three Ages of Woman*. The little curly-haired child reminds me of one of my boys, and I wanted to capture our snuggles in flowers.

Original: The Three Ages of Woman *by Gustav Klimt (Austrian, 1862–1918), 1905. Oil on canvas, 70.8 inches x 70.8 inches.*

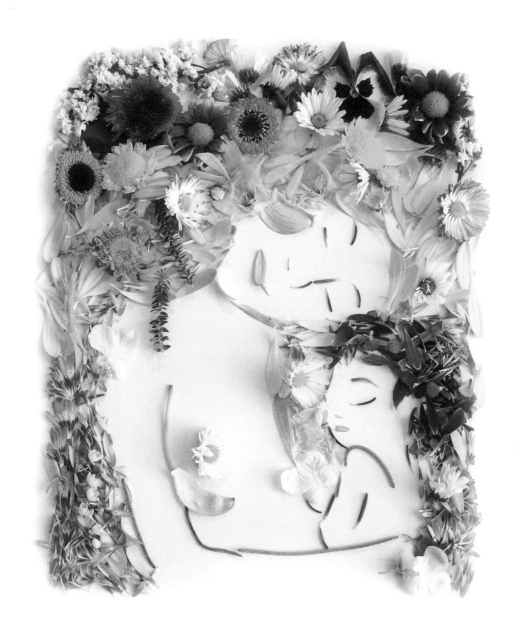

Botticelli's The Birth of Venus

Carnation, chrysanthemum, daisy, goldenrod, Lenten rose, marsh rosemary, primrose, sunflower, tulip, woolly lavender

For me Italy is a place of fanciful delights, where frivolity and beauty aren't just admired, but are lavished on the buildings, food, gardens, and artwork. When I visited Sandro Botticelli's *The Birth of Venus* in Florence I loved how his paintings were like windows looking out on a dreamy fantasy world. In the original, Venus is being showered with pink flowers by angels and the color scheme is more pastel. My version is brighter, but I tried to keep the same dreamy, playful quality by recreating Venus's flowy hair with sunflowers and goldenrod.

Original: The Birth of Venus *by Sandro Botticelli (Italian, 1445–1510), 1482–1485. Tempera on canvas, 67.9 inches x 109.6 inches.*

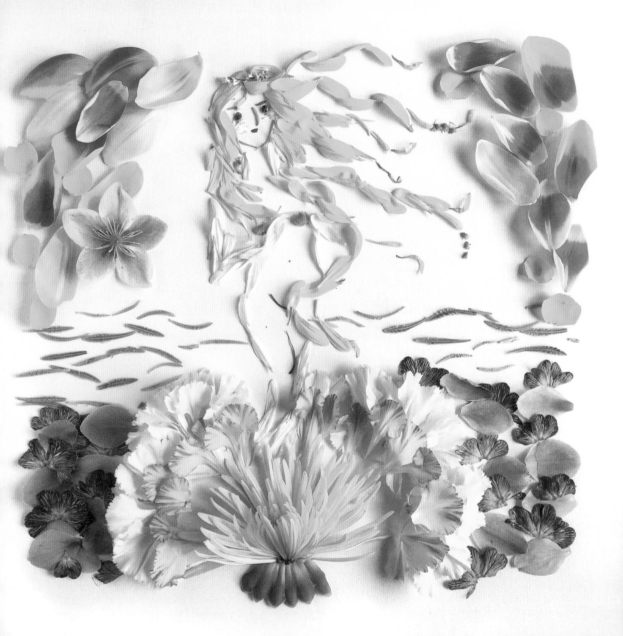

Hokusai's Under the Wave off Kanagawa

Bluebell, California lilac, cherry blossom, narcissus, pixie's parasol
mushroom, purple sage, rhododendron, tansy

When I studied Asian art history in college, my favorite things
were wood-block prints and the floating world of Ukiyo-e, an
underground art form from the seventeenth, eighteenth, and
nineteenth centuries that depicts a hedonistic lifestyle in a dreamy
way. When I went to Japan, I got to make my own print from
old carved blocks! I tried hard to recreate the three levels in this
image: the mountain in the distance, the wave itself, and the
mirror of them in the clouds.

Original: Under the Wave off Kanagawa *by Katsushika Hokusai
(Japanese, 1760–1849) 1830–1832. Color woodblock print, 10.1
inches x 14.9 inches.*

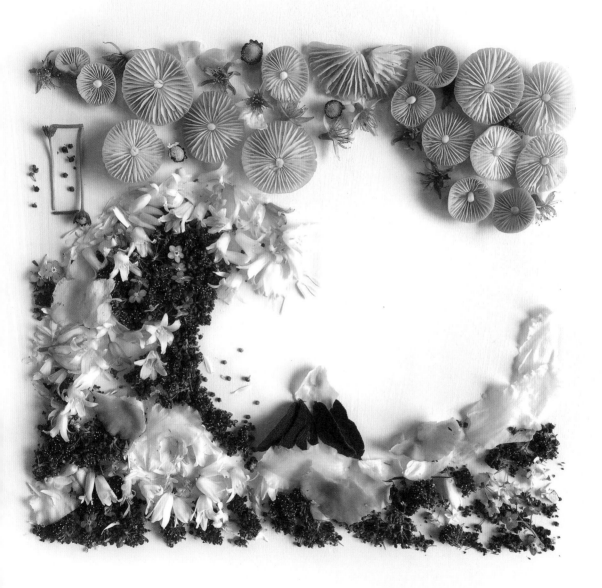

da Vinci's Mona Lisa

Chrysanthemum, dahlia, lamb's ear, lavender, pinecone, red maple leaf

Before I went to the Louvre in Paris, everyone warned me the *Mona Lisa* would be anticlimactic. I entered the crowded room, stood in the middle of hordes of people shoving each other to get a picture, and looked up. I cried as if I was all alone. Leonardo da Vinci captured a woman who could speak to me through time with nothing but an enigmatic smirk. My version is rose colored, because that's how I remember her.

Original: Mona Lisa *by Leonardo da Vinci (Italian, 1452–1519) 1503–1519. Oil on poplar, 30 inches x 21 inches.*

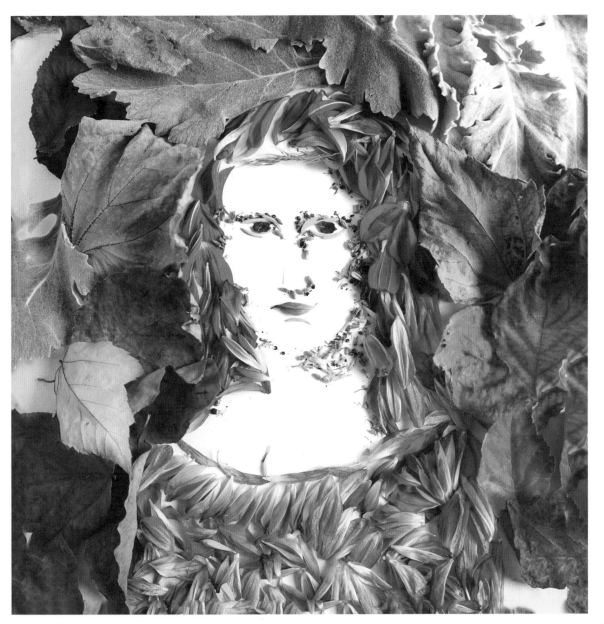

FANTASY

I love fantasy. I grew up playing make-believe, always a fairy, elf, Jedi, or Narnian. I would stay up late on summer nights sneaking light from my window to read about other worlds and daring adventures. Now, as I get older, I realize more and more that our own world is a magical place, as long as you know where to look.

Firebird

Forsythia, grape hyacinth, Matsumoto aster, orchid, Oregon grape flowers, protea

I saw the wings of this firebird in the feathery petals of a queen protea in a flower shop. The petal tips were black and fuzzy, like singed feathers! All it needed was a few touches and some flower sparks, and that tropical flower was reborn as a bird!

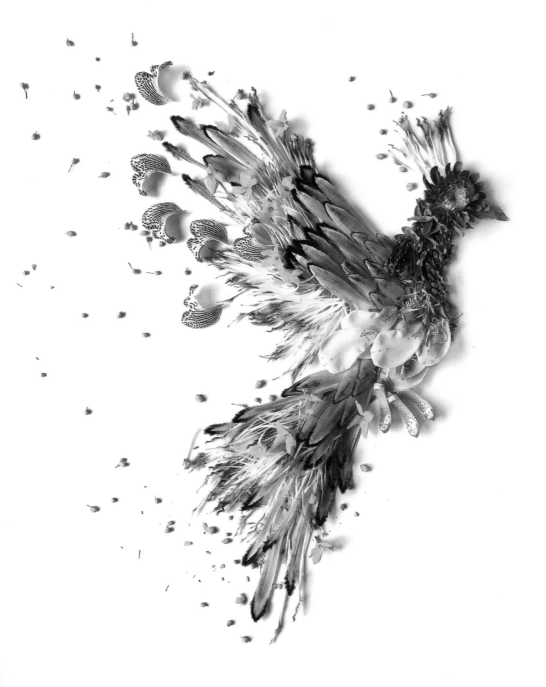

Hobbit Hole

Bean vines, blanketflower, camellia, lavender, Peruvian lily, Queen Anne's lace, rhododendron, St. John's wort, sunflower, sweet William

I grew up reading The Lord of the Rings and *The Hobbit*, wishing I could be one of the elves living in Lothlórien. A couple of years ago I traveled to New Zealand and visited the Hobbiton movie set. It looks as if it's always been there, a home for hobbits since the Middle Ages. My favorite part was the gardens tucked around those little round doors, urging me to open them, go in and make myself at home.

"I wish I was at home in my nice hole by the fire, with the kettle just beginning to sing!"

—J. R. R. TOLKIEN, *THE HOBBIT*

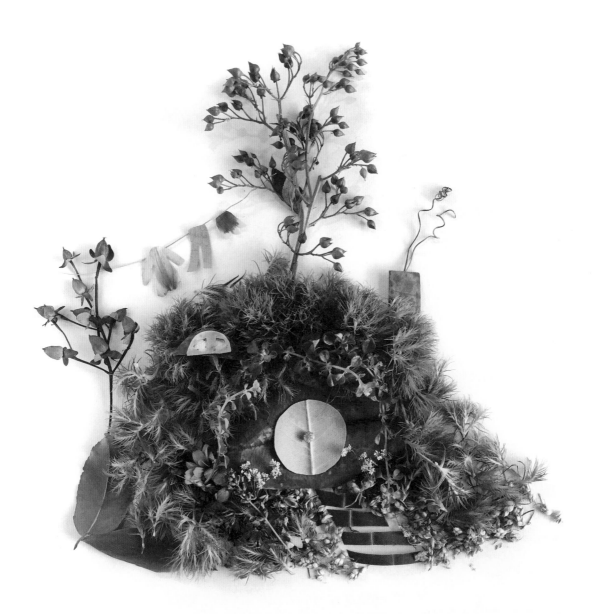

Mermaid

Butterfly bush, chrysanthemum, forget-me-not, geranium, gerber daisy, lichen, orchid

My sister Lucy has always reminded me of a mermaid. She has beautiful thick, long blond hair and loves seashells. She lived on a little island in Honduras for a couple of years and would talk about swimming with leopard rays and finding hoards of conch shells. When she got married, I threw her a mermaid shower with seashell crowns, a sandcastle cake, and lots of sparkly aqua tulle. This floral mermaid is for her.

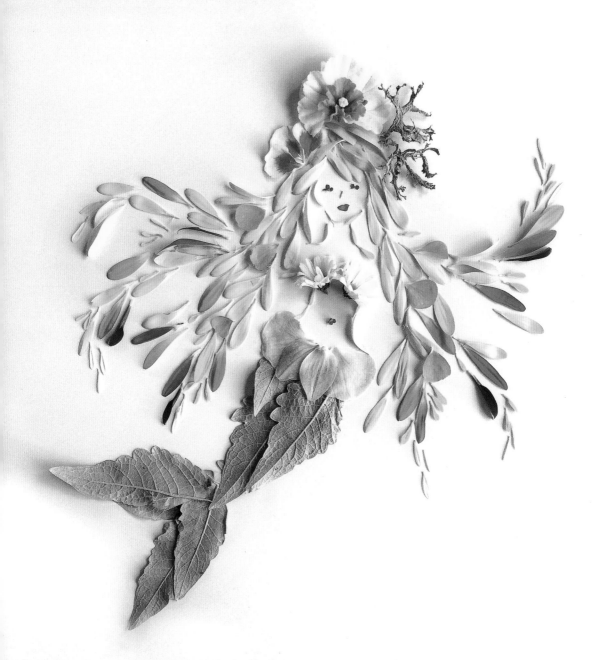

Garden Gnome

Bellflower, daisy, forget-me-not, mushroom,
primrose, rose

Gnomes make me so happy. I have a tiny one in
my herb garden; it's the guardian of the patch.
There are a bunch of gnomes in random spots in
my neighborhood, and I like to imagine they all
come to life when nobody is looking. I used to
imagine myself a fairy in an imaginary world, and
I told my little sister Jamie that she would be a
gnome in that world. This piece is for her.

Gandalf

Bells of Ireland, clematis seeds, lilac twig, mallow leaf

I love the idea of a wise soul who gives sage
advice, encourages you to adventure, trusts you to
be brave, and makes wildly outlandish firecrackers.
I hope I am half as magical as Gandalf when I
reach a wizardly age.

Loch Ness Monster

Clover, daisy, dill, eucalyptus, firethorn berry, goldenrod,
hydrangea, poppy, rose, rose leaf

I've scanned Loch Ness's silver waters hoping for
a glimpse of that mythic creature. I won't tell you
whether or not I saw it; only that magic is thick
in the air of Scotland, and if you venture there, be
prepared to believe!

Unicorn

Camellia, chrysanthemum, daisy mum, dusty miller,
Peruvian lily

Nothing can convince me that unicorns aren't
real. If Narwhals have horns and birds have wings,
why can't horses? I'm sure the last unicorn will
someday return, and I'll fly off on its back to a
land of rainbows and stardust.

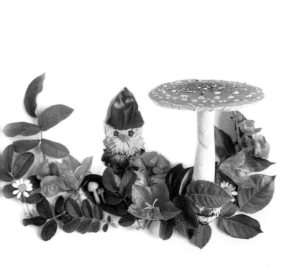

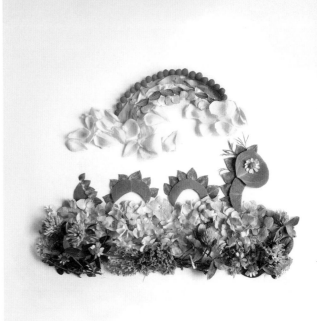

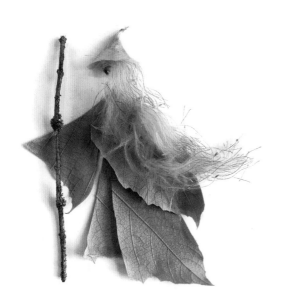

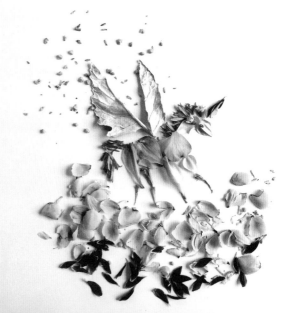

Kraken

Black maple leaf, dahlia, dusty miller, flamingo cockscomb, hydrangea, pumpkin vine, red maple leaf, seaberry

A friend of mine told me about a plant that looked "just like a creature!" and how she was tempted to steal it from her neighbor's window box so I could use it. I told her to just take a picture so I could see it. It was a type of celosia (called flamingo cockscomb), all wilted from the frost, and it *did* look like a creature of the deep! Eventually I bought a plant of my own for my garden and made it into the creature my friend had envisioned.

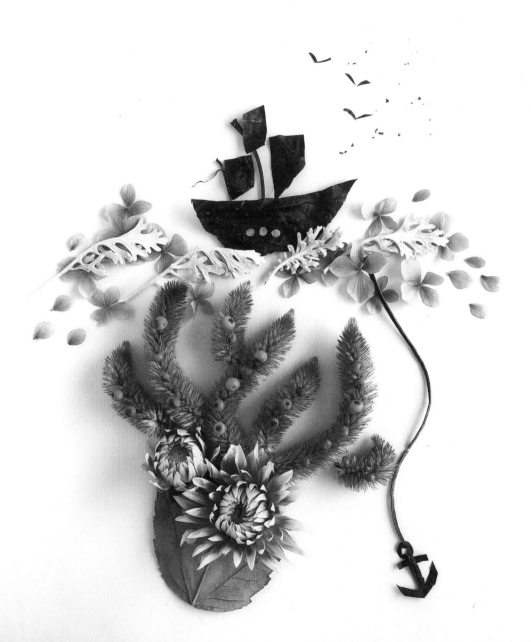

Dragon

Camellia, daisy mum, holly-leaved hellebore, nerve plant, prayer plant, sunflower, tulip

When I was a little girl, I was surprised on my birthday with a pet Mountain Horned Dragon. She was such a sweet creature. She loved to be petted and would perch on my shoulder as I read. Hers was the very first death I experienced, and I remember crying as I buried her in a gold box in my mother's garden. Ever since then I have had a softness for scaly beasts.

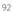

ICONIC WOMEN

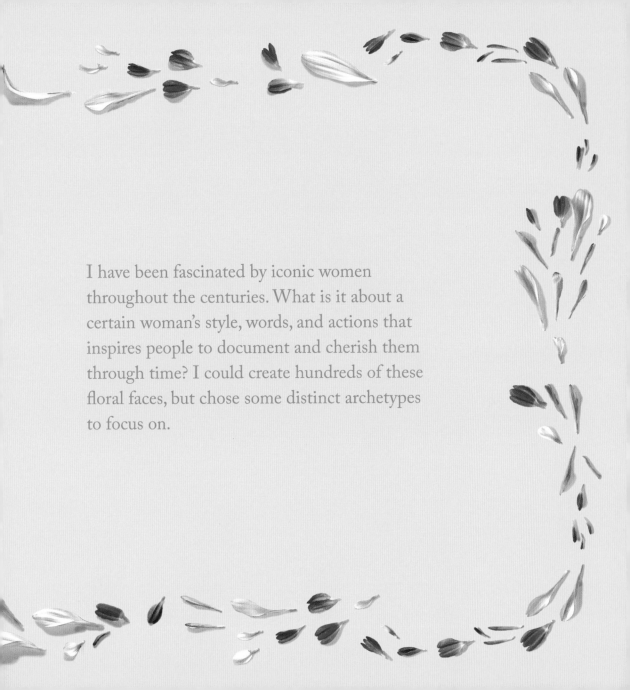

I have been fascinated by iconic women throughout the centuries. What is it about a certain woman's style, words, and actions that inspires people to document and cherish them through time? I could create hundreds of these floral faces, but chose some distinct archetypes to focus on.

Frida Kahlo: The Artist

Beautyberry, Canada thistle, chrysanthemum, gerber daisy, ornamental millet, Peruvian lily, rose, rose thorn, seaberry

I feel a connection with Frida. Her art depicting sorrow from miscarriage moved me deeply when I had my own. Her love of creature and flower crowns resonates with me too. I like to think if I had known her we would have been friends. For this piece, I chose a necklace of thorns, copying one of the elements of her own self-portraits.

"I paint flowers so they will not die."

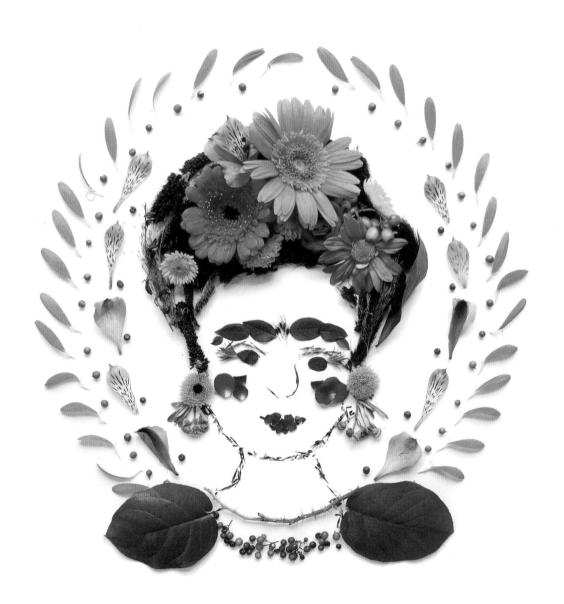

Marie Antoinette: The Queen

Baby's breath, begonia, carnation, grape, hydrangea, lily, ranunculus, rose

A woman who was born into decadence but longed for simple country life. She may have had a naive and idealized view of the world outside her palace, but her garden and coiffed extravagant style remain a rose-colored window into the world before the revolution.

"Let them eat cake!"

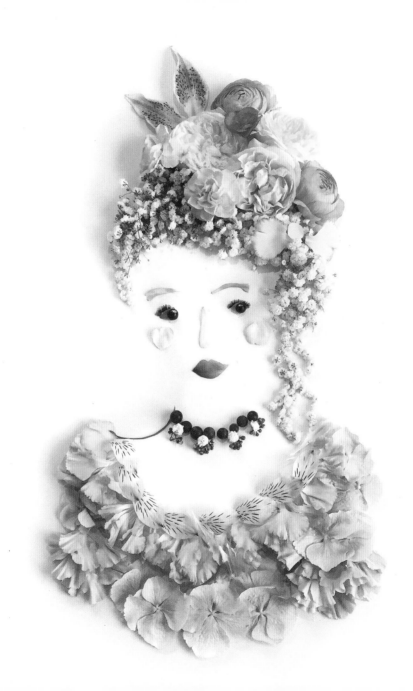

Marilyn Monroe: The Sex Symbol

Cedar, geranium, oak leaf, parsley, yarrow

In my mind no one has yet surpassed Marilyn for unadulterated, oozy sex appeal. She had the hips, the come-hither flirty attitude, the doe-eyed innocence mixed with syrupy-sweet talent. Her scene in *Some Like It Hot* where she sings and dances with a ukulele, shakes her girls and tail, winks, and then ends with her liquor flask falling out of her skirt is one of my favorites.

"We are all born sexual creatures, thank God, but it's a pity so many people despise and crush this natural gift. Art, real art, comes from it, everything."

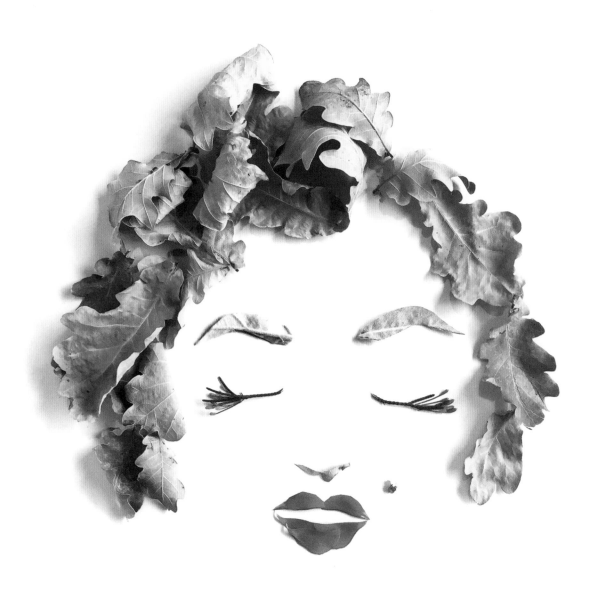

Audrey Hepburn: The Ingenue

Bluebell, cherry blossom, clematis, daisy, juniper, smoke bush

During my teenage years I wanted to be Audrey Hepburn. I cut my dark hair short, wore pedal pushers, and fluttered around my high school like Holly Golightly. When I got married, I had a dress designed like the one she wore in Funny Face. I adore her impish face, darling speech, graceful movement, and selfless heart.

"To plant a garden is to believe in tomorrow."

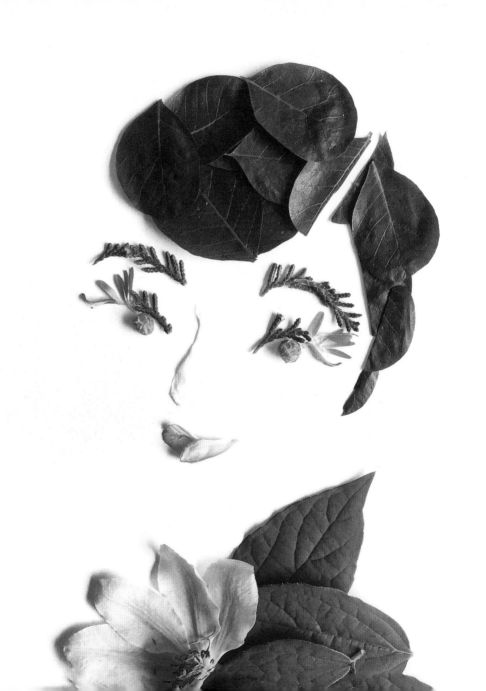

Lucille Ball: The Comedian

Billy button, birch leaf, firethorn, lavender, spiderwort

Growing up, so many boys told me girls can't be funny. We were supposed to be demure, quiet things laughing at the boys' jokes. Well, that's a bunch of nonsense! Lucy taught me it's cute to be ridiculous and to stuff your face with chocolate.

"Do you pop out at parties? Are you unpoopular?"

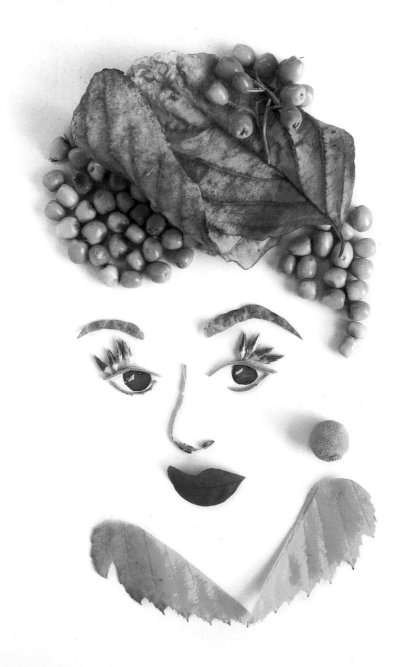

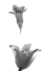
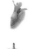

Diana Ross: The Diva

Amaranth, black elder, dahlia, hyacinth beans, Zahara zinnias

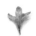

My first experience with Diana Ross was lip-synching to Supremes songs with my sisters, then loving her in The Wiz as a little girl, and then later, in my teens, watching her outshine everyone in Divas on VH1. I love her charisma, her groove, and her hair!

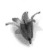

"You can't just sit there and wait for people to give you that golden dream. You've got to get out there and make it happen yourself."

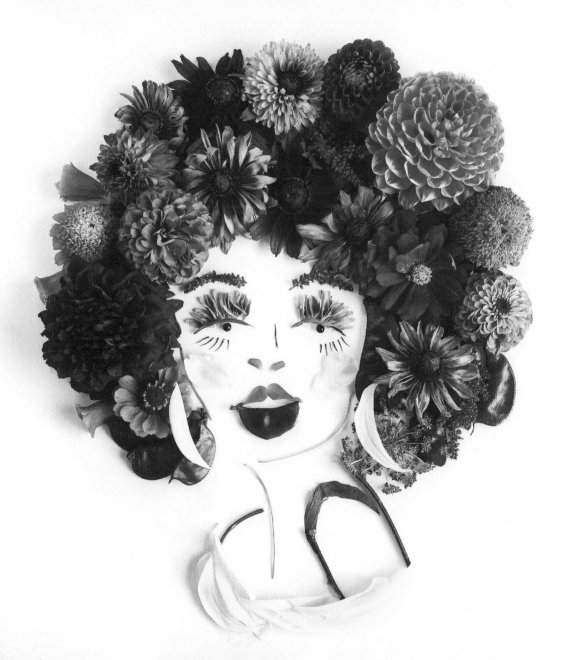

Marie Curie: The Scientist

Chinese silvergrass, freesia, gerber daisy, gold dust dracaena, lavender, Oregon grape leaf, pink stripe New Zealand flax, poinsettia

Marie Curie studied glowing rocks in her laboratory, discovering and naming them radium and polonium. She won the Nobel prize in chemistry *and* physics, was the first female professor in France, and spent years researching to advance medical science. I imagine her playing with magical elements, a philosopher's stone of sorts, the effects of which would cause many deaths and pain but eventually would lead to prolonging lives. Marie Curie died of bone marrow loss from the rocks she kept in her pockets. Even her notes and research are so full of radiation they are now sealed in lead boxes. But years later I was personally affected by her important work: when I was young, my mother got cancer, and radiation saved her life.

"A scientist in his laboratory is not a mere technician: he is also a child confronting natural phenomena that impress him as though they were fairy tales."

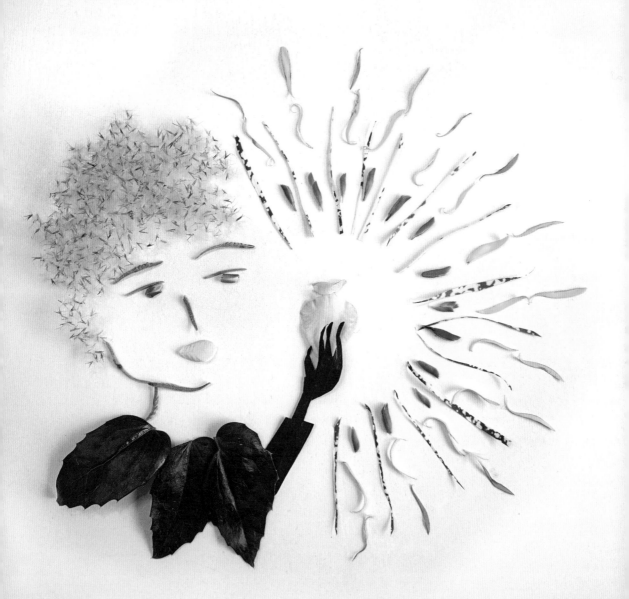

ANIMALS

Flora Forager, my Instagram account, began as an abstract account with mandalas and glossaries of plants. I really thought nobody would care much for something quirky like my floral animals. Then one day I posted three snails made from escargot begonias. (I thought I was being pretty clever!) To my delight, there were plenty of people who loved my idea. Now Flora Forager has a menagerie of floral friends. A veritable zoo!

Leopard

Camellia, pansy, Peruvian lily, seaberry

Peruvian lilies have perfect spots and "whiskers" for a leopard.
Every time I see a bouquet of them they remind me of spotted
cats! They would fit in with tiger lilies and dandelion.

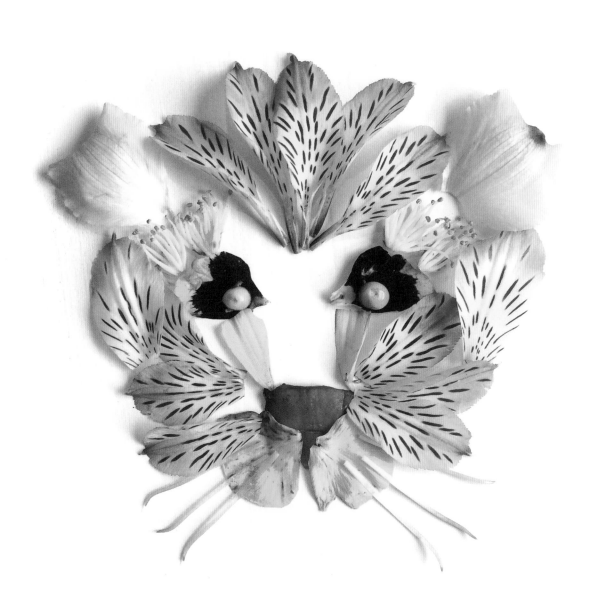

Chameleon

Calla lily, camellia, fiddlehead fern

Snake

Blue spurge, cedar, privet, sedum

Lion

Black elder, dandelion, geranium, hydrangea, moss, rhododendron leaf, sunflower

Red Panda

Acorn, maple leaf, Oregon grape, pumpkin seed, rowanberry

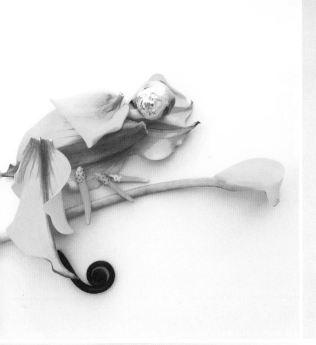

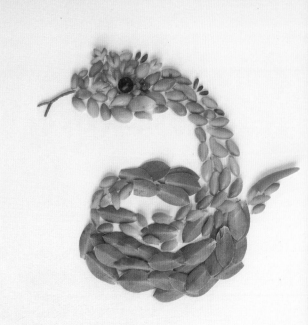

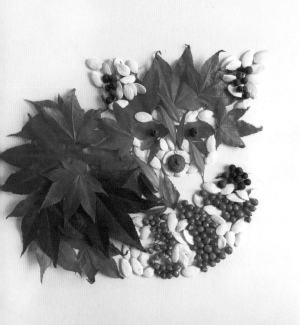

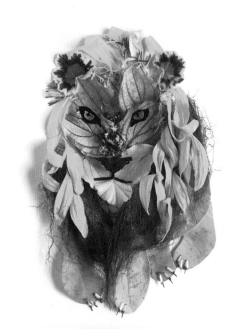

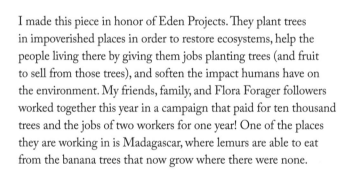

Lemur

Black elder leaf, camellia, gerber daisy, lavender leaf, mallow leaf, mallow seeds, tulip leaf

I made this piece in honor of Eden Projects. They plant trees in impoverished places in order to restore ecosystems, help the people living there by giving them jobs planting trees (and fruit to sell from those trees), and soften the impact humans have on the environment. My friends, family, and Flora Forager followers worked together this year in a campaign that paid for ten thousand trees and the jobs of two workers for one year! One of the places they are working in is Madagascar, where lemurs are able to eat from the banana trees that now grow where there were none.

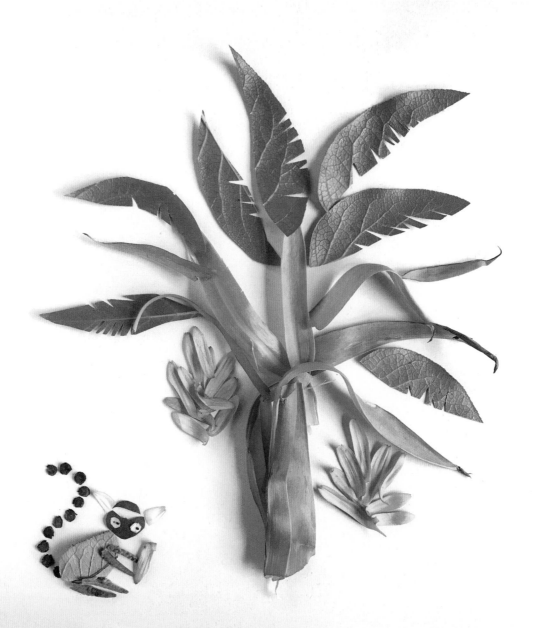

117

Giraffe

Dandelion, forget-me-not, pansy

Elephant

Chrysanthemum, daisy, orchid, Peruvian lily, spiderwort

Snails

Coneflower, escargot begonia, nasturtium

Panda

Bamboo, black elderberry, lacecap hydrangea

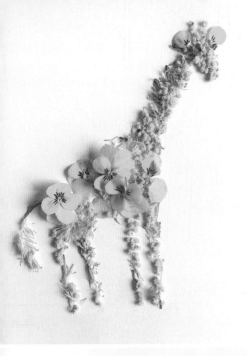
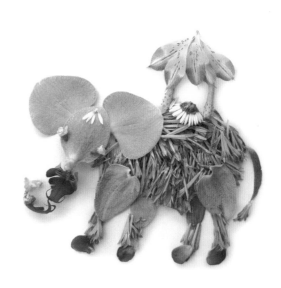
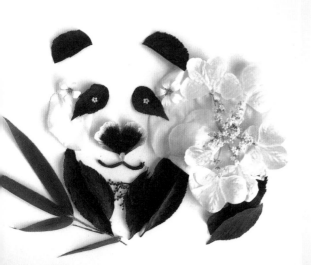
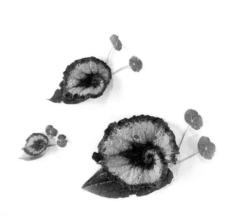

Rhinoceros

Bellflower, daisy, delphinium, rose thorn, waxflower

T-rex

Porcupine tomato, rex begonia, Under the Sea gold anemone

Seal

Forget-me-not, purple shamrock, violet

Sloth

Black elder, blueberry, clematis, eucalyptus, hydrangea, lamb's ears, pine needle

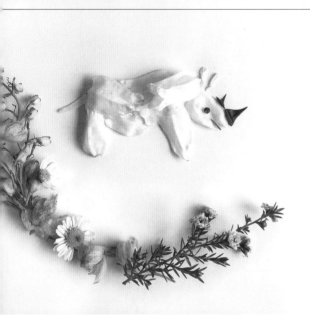

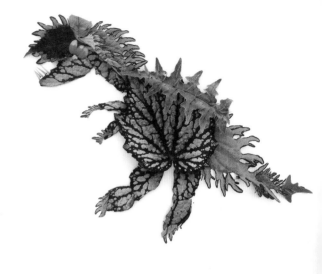

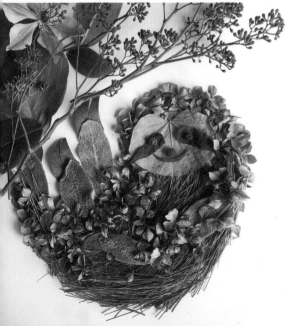

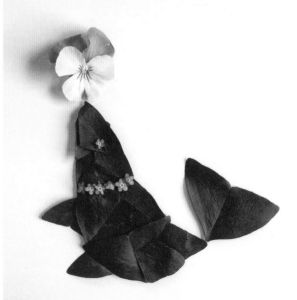

BIRDS

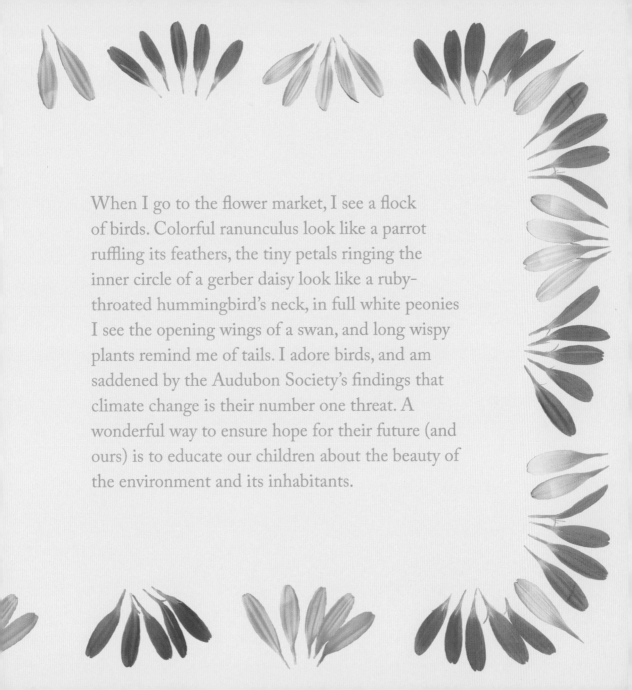

When I go to the flower market, I see a flock of birds. Colorful ranunculus look like a parrot ruffling its feathers, the tiny petals ringing the inner circle of a gerber daisy look like a ruby-throated hummingbird's neck, in full white peonies I see the opening wings of a swan, and long wispy plants remind me of tails. I adore birds, and am saddened by the Audubon Society's findings that climate change is their number one threat. A wonderful way to ensure hope for their future (and ours) is to educate our children about the beauty of the environment and its inhabitants.

Peacock

Beautyberry, camellia, cedar, chrysanthemum, dahlia, geranium, grass, hydrangea, sea lavender

Nature has no rules about fashion. I love how the brightest, most colorful frocks are worn by male peacocks. And a group of them are called an ostentation!

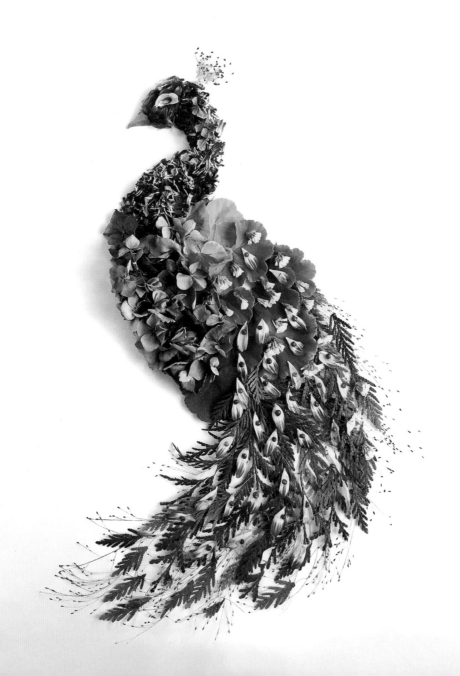

Hawk

Beautyberry, chrysanthemum, daisy mum, gerber daisy

Cockatiel

Begonia, cedar, dusty miller, geranium, hollyhock seed, Queen Anne's lace, snowberry, sunflower, yarrow

Parrot

Black elder, camellia, daisy, ranunculus, tulip

Flamingo

Camellia, carnation, dahlia, lace leaf Japanese maple, pansy, privet, pumpkin vine

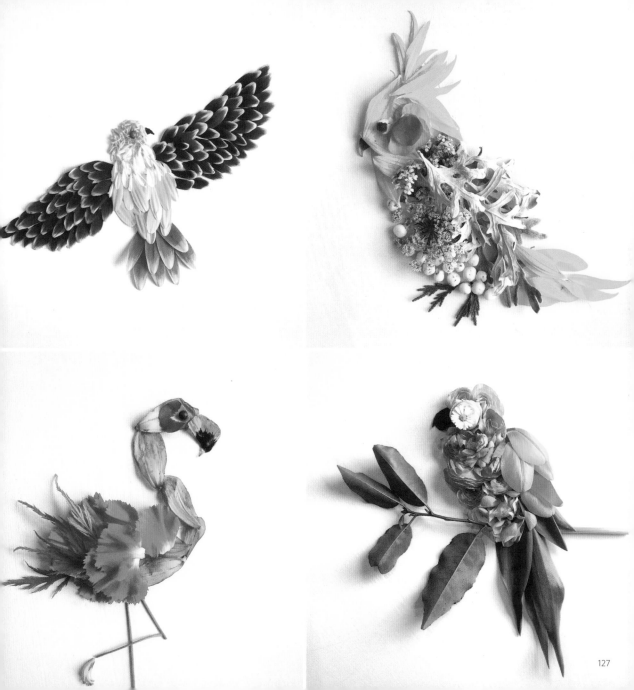

Cockatiel Swing

Camellia, daisy, fern, forsythia, lavender, spiderwort

I adore the round cheeks and feather fluffs on cockatiels. They look like little circus performers doing acrobatics on their perches. For this sweetheart's head tuft I used the forsythia that blooms in my garden. It's the first color that pops out of the gray in spring and is often accompanied by birds!

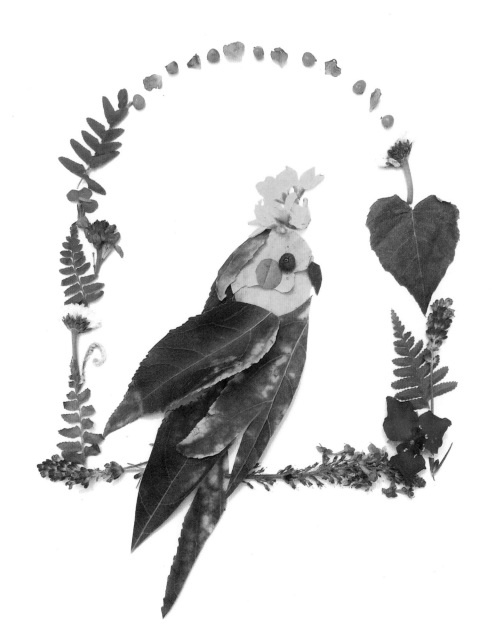

Cardinal

Black elderberry, pine, pinecone, poinsettia, rowanberry

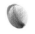

Bird of Paradise

Chinese silvergrass, dahlia, everlasting, pampas grass, rhododendron

Finches

Bellflower, cyclamen, everlasting, gerber daisy, mallow, privet, sunflower

Ostrich

Chamomile, dianthus, dogwood, pansy

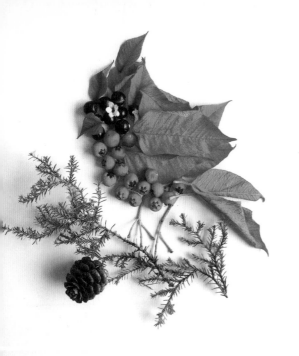

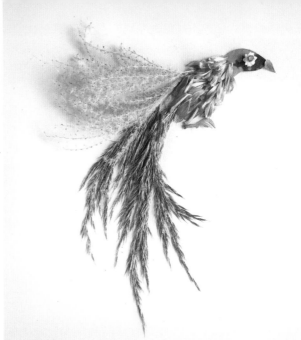

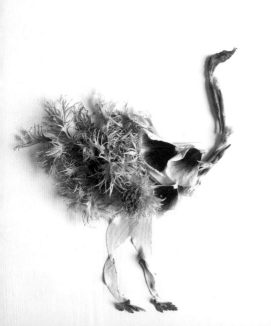

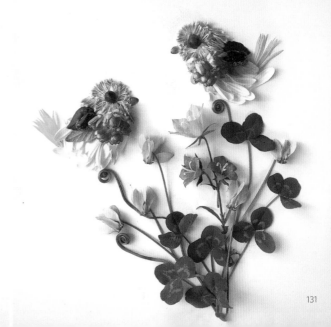

131

INSECTS

Honey, silk, fruit, and flowers: those are the gifts
we get from the insect world. So many people are
frightened of moths and spiders, yet they search
for the stars and weave silken threads. And bees
may sting, but they pollinate groves all over the
world. Insects can mimic flowers, light up, and
create whole cities underground. I love discovering
new things about them. Infinite possibilities from
finite beings.

Butterfly Meadow

Fern, gerber daisy, pansy, rose, sea lavender, widow's-thrill, yarrow

Sometimes the best design is to just let nature do the work. In this case, pansy petals make great butterfly wings, with their delicate black stripes and rim of color around the edges. I'm continually amazed by how often insects mimic nature and vice versa.

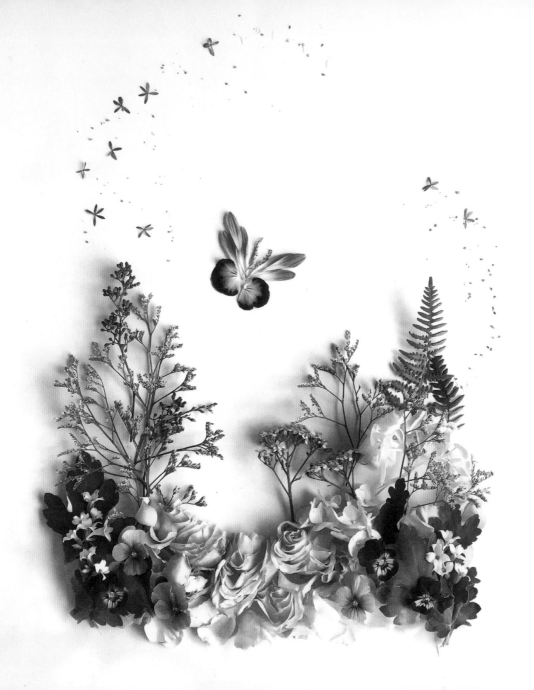

Butterflies

Daisy, dill, Iceland poppy, parrot tulip, primrose, stargazer lily, stock

Butterfly

Anise, blanketflower, butterfly bush, coneflower, geranium, hydrangea, lavender

Grasshopper

Feverfew, grass, lemon verbena, mallow, rhododendron

Bee

Bee balm, St. John's wort, sunflower, zinnia

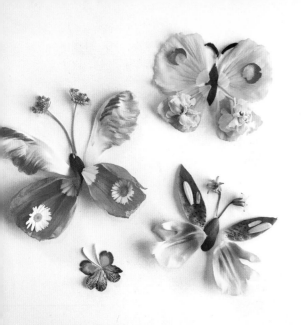
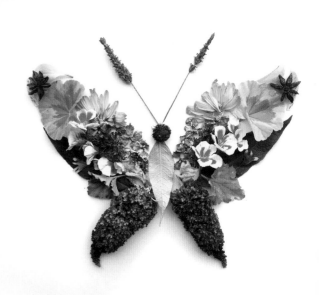
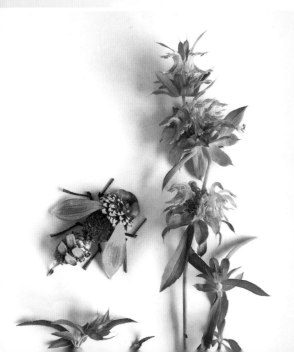
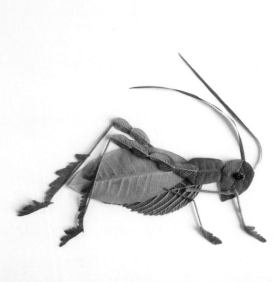

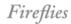

Fireflies

Black maple leaf, chrysanthemum, dahlia, grass, lamb's ears,
snowberry, yarrow

We don't have fireflies where I live, and I've seen fireflies only
three times in my life, in Indiana, Italy, and Honduras. They
were all completely different. The ones in Indiana swirled in lazy
swarms near the path, ready to be caught in a jar. The ones in Italy
congregated on the tiers of a villa garden and turned on and off in
jagged orchestral unison. And the ones in Honduras were high up
in the trees, barely visible. We climbed up to the roof and watched
them in the jungle canopy as the sky turned from pink to black.
They are the nearest thing to fairies I have seen.

Moth

Cherry tree leaf, gerber daisy, maple leaf, rose leaf, sunflower

Spider

Blueberry, privet, yew

Dragonfly

Euphorbia pods, globe thistle, mimosa, snow-on-the-mountain
(euphorbia marginata)

Caterpillar

Alder, gold dust dracaena, privet, sea holly, wintercreeper

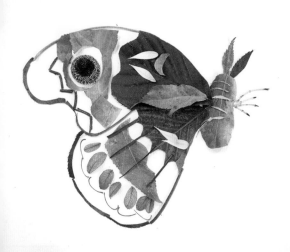

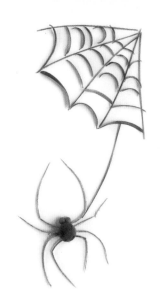

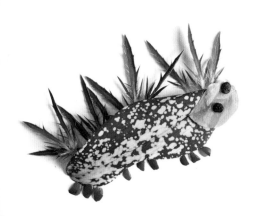

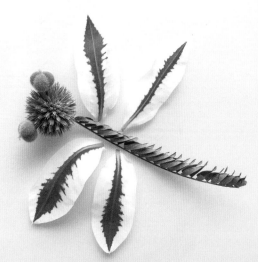

SEA LIFE

Years before Flora Forager, fish were the very first floral art I made. One day while I was walking through my garden, the petals of an orange poppy caught my eye. They looked exactly like goldfish fins to me. I plucked the flower, brought it into my kitchen, and made a fish. That spawned several other floral fish and, eventually, what is now known as Flora Forager.

Goldfish

Daisy, orange wild flower, poppy

Sea Horse

Cherry blossom, chrysanthemum, cyclamen, globe thistle, privet, sunflower

Angel Fish

Bells of Ireland, dahlia, mallow, zinnia

Sea Turtles

Azalea leaf, California lilac, lemon bud, pineapple periwinkle

Succulent Whales *(next page)*

Echeveria, mum, paddle plant, sedum, succulent

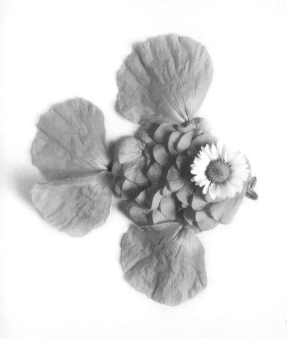

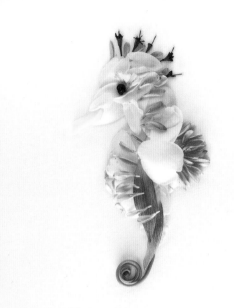

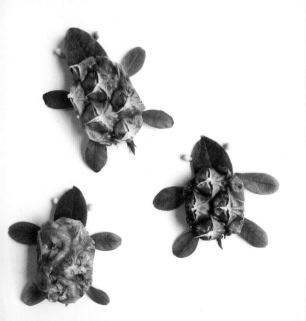

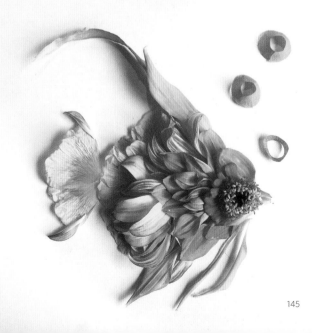

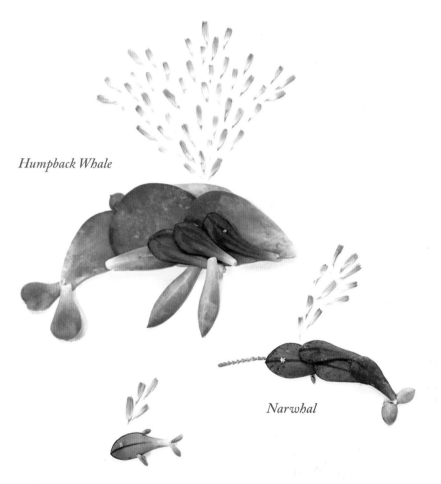

Humpback Whale

Narwhal

Vaquita Porpoise

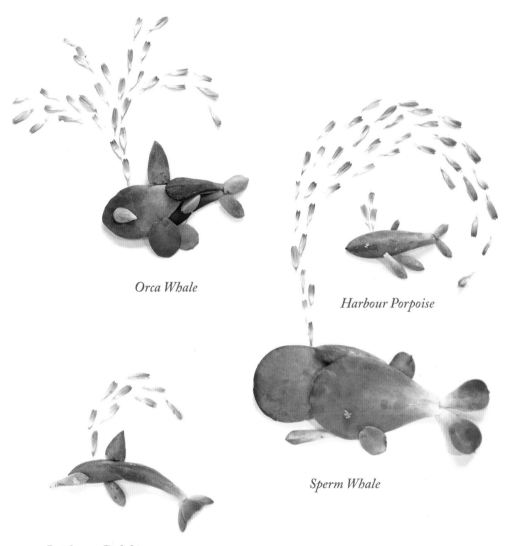

Orca Whale

Harbour Porpoise

Bottlenose Dolphin

Sperm Whale

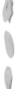

Jellyfish

Begonia, cedar, chestnut, chrysanthemum, cockscomb, dried lace leaf, dusty miller, globe thistle, honesty, Japanese maple leaf, lichen, mushroom, seaberry, spiderwort, various leaves

When I take my boys on mushroom hunts in the fall, I can't help but feel like I've stumbled upon a swarm of jellyfish. There is even a type of mushroom called coral fungi! And lichen and succulents make a perfect undersea reef.

BITS & BOBS

Sweets, frills, travels, and bright colors, "these are a few of my favorite things." I love playing with florals for the sole purpose of making people smile.

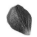

Lemon Bicycle

Leatherwood, lemon, pansy

Cupcake

Boxwood, camellia, chocolate sunflower, daisy, hydrangea, rose, tulip

Old Fashioned

Cardamom, chamomile, clove, dill, forsythia, grape, leatherwood, mint, mugwort, orange, sea thrift, star anise

Balloons

Pumpkin vine, tomato

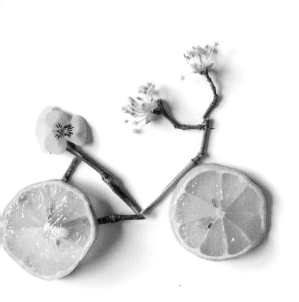

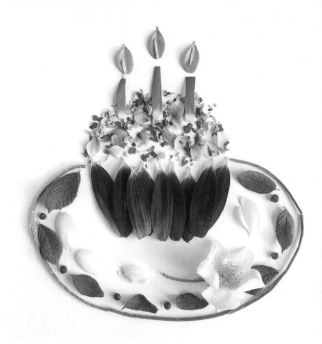

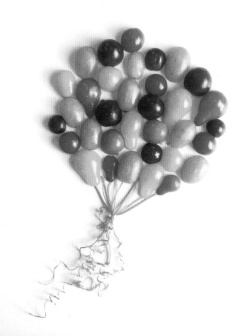

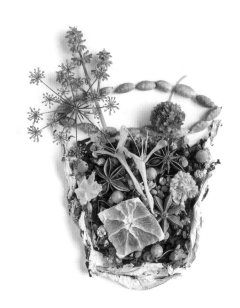

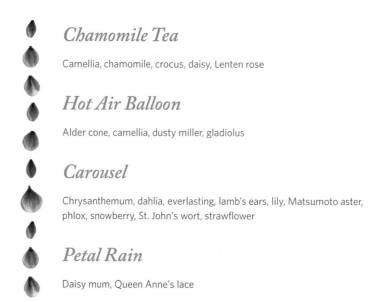

Chamomile Tea

Camellia, chamomile, crocus, daisy, Lenten rose

Hot Air Balloon

Alder cone, camellia, dusty miller, gladiolus

Carousel

Chrysanthemum, dahlia, everlasting, lamb's ears, lily, Matsumoto aster, phlox, snowberry, St. John's wort, strawflower

Petal Rain

Daisy mum, Queen Anne's lace

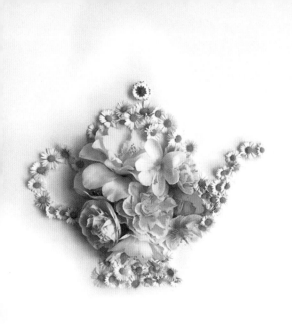

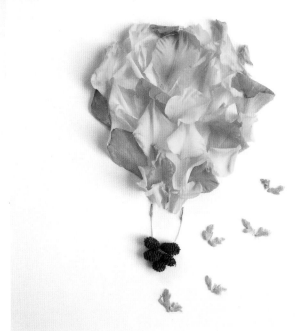

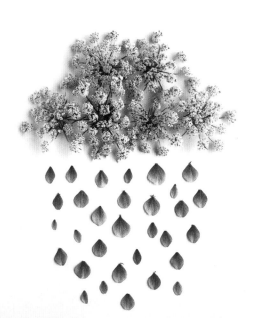

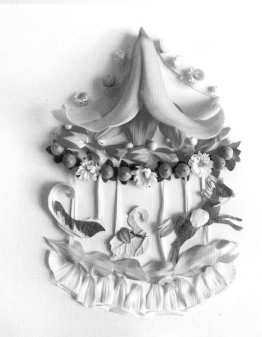

Ice Cream

Blueberry, camellia, cherry leaf, hellebore, pieris, primrose, privet, red elderberry

Campfire

Acorn, alder cone, forsythia, Indian plum, rowanberry, sunflower

Popcorn

Begonia, lentils, raspberry

Copper Kettle

Daisy mum, lily, St. John's wort

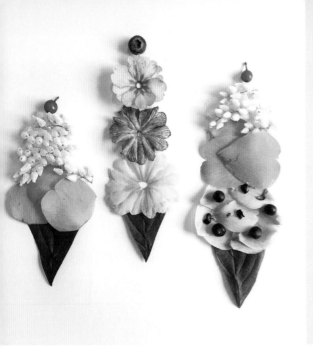

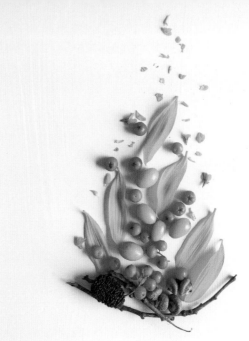

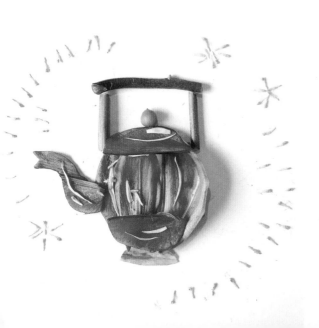

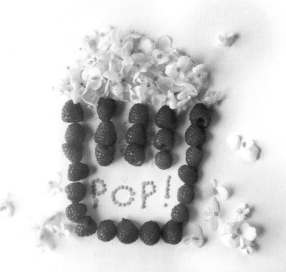

FOR MY BOYS

I have three little boys named for book characters;
Finn, Oliver, and Harry. They are the stars of my
life and inspire much of what I create. They love
to bring me flowers and specimens to use in my
art. Sometimes they find things I might not have
noticed! These pieces were made especially for them.

Knight and Dragon

Begonia, dusty miller, hydrangea, lily, sunflower

The very first thing I bought when I found out I was having a baby boy was a dragon stuffy. We named it Smaug, and it was Finn's favorite thing when he was a baby. My boys love vanquishing imaginary foes with sticks and battling dragons to save the princess. (And I get to be the princess!)

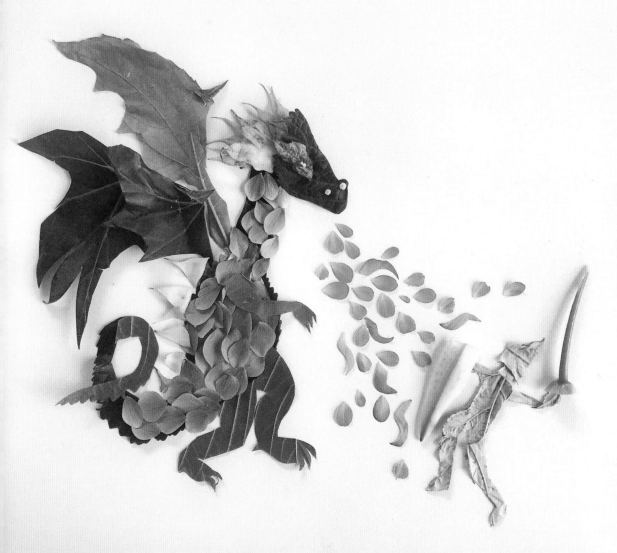

Harry Potter

Black elder, daisy, daisy mum, goldenrod, lavender, lily, sunflower

My Harry is named for the boy wizard. Oh, the love I have for those books! Finn is slowly making his way through them, and we watch the movies after he finishes each one.

Pikachu

Black elder, geranium, mallow, sunflower

My boys are obsessed with Pokémon! Oliver had a Pokémon birthday party this year, and Finn immersed himself in the world of Pokémon GO. Okay, I admit, we all did. Finn helped me find Pikachu, and I was like a little girl jumping up and down in the street!

Castle

Fern, ivy, lavender, moss, privet, rowanberries, snowberries

My youngest, Harry, loves castles. One day I told him the old brick observatory near our house was a castle, and he was so delighted when he got to go inside and climb all the steps to the top. That day we found a bunch of red mushrooms growing in a circle by the door. It was truly magical!

Tinker Bell

Geranium, goldenrod, mallow, sunflower

Finn's favorite character was Tinker Bell when he was little. I took him to Disneyland to meet her in Pixie Hollow, and he nearly fainted for happiness when he saw her. He asked her, "When will you fly?" She told him to look up at the castle during the fireworks. Finn fell asleep in my arms that night after oohing and aahing at Tink in the sky.

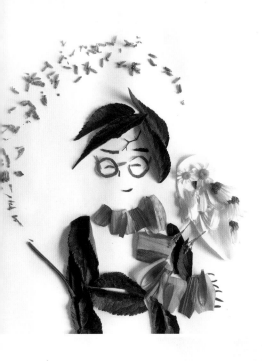

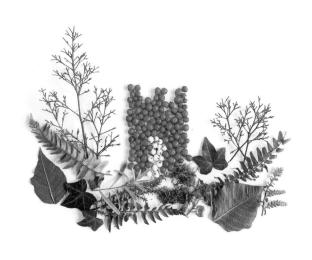

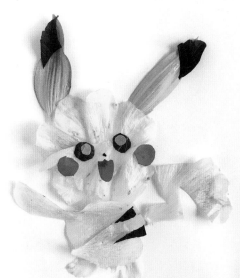

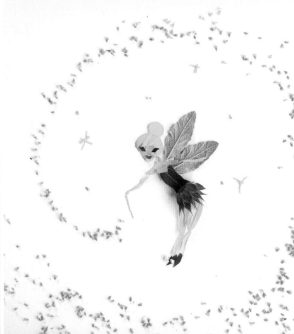

Flower Wars

R2-D2: Daisy, hydrangea, lily, mimosa, seaberry
C-3PO: Daisy, gerber daisy, grass, mimosa

I took Finn to the theater to see *Star Wars: Episode VII* and it was
one of the most exciting experiences I've had. Seeing something
you love through the eyes of your children is twice the fun! His
favorite character is now BB-8, so I'll have to make another droid!

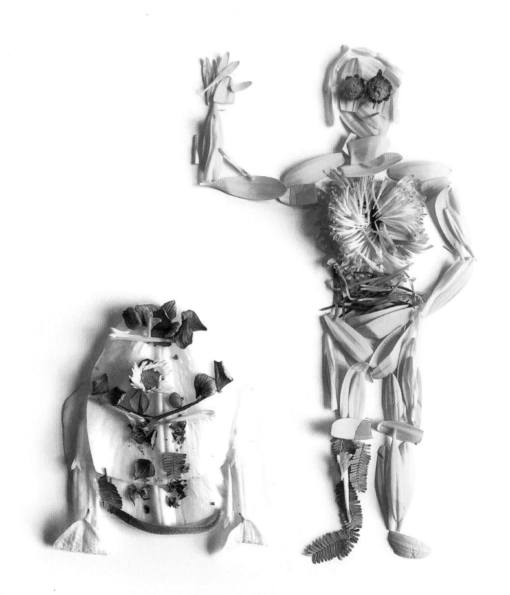

Acknowledgments

I would like to thank . . .

Beau: for letting me fill every nook and cranny of our lives with a mess of petals . . . and loving me for it.

Finn, Oliver, and Harry: for being the twinkles in my eye, and showing me who I am.

My Mom: for her bounty of garden roses, love, decadent dinners, and grammar corrections through the years.

My Dad: for teaching me to love science, birds, botanical specimens, and endless fun.

My sisters, Lucy and Jamie: for being silly, true, and lovers of magic.

My Grandma Mary: for being my example of how flowers gone to seed can be the most beautiful.

Those who have given me flowers, written excited texts, or gone with me on an adventure: for encouraging this small seed to grow.

My editor, Hannah, and my agent, Cindy: for being cheerful believers in me.

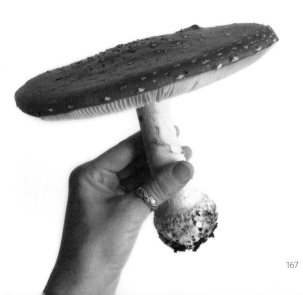

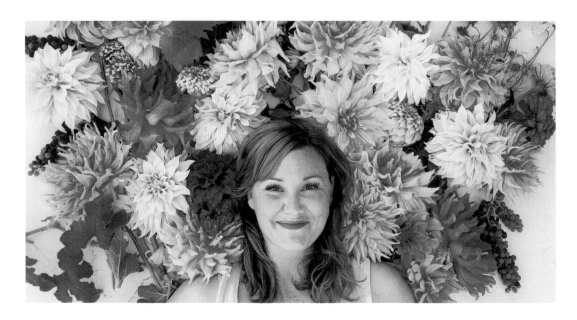

About the Artist

Flora Forager sprung to life after a day of hunting for berries with my three little boys. I charged them with finding as many different colors as they could in our lush Seattle neighborhood. "Pink!" "Black!" "Yellow!" They cheered as they reached up to grab our treasures. We came home and made a rainbow on our kitchen table, and I took some photos.

Our berry rainbow planted the idea for a whole gallery made entirely of floral art: a way for us to connect through nature and an artistic endeavor for myself.

I have been enamored with flowers since I was very young. Growing up in the Pacific Northwest in the small seaside town of Edmonds, Washington, I spent my childhood playing in the forest, learning the names of flowers, and turning my thumbs green in my mother's extensive rose garden, which she coaxed into bloom from tiny sprigs.

I graduated from Seattle Pacific University with a degree in theater and spent much of my younger years learning to paint watercolors. Having a knack for drama and an eye for color has helped me create my whimsical style of artwork: painting with petals.

While wandering the woods or meandering through a meadow, a magical world of animals, fairy landscapes, and beautiful patterns is revealed to me.

My very first floral animal was a goldfish. I saw its fins in the petals of one of my orange poppies and brought the flower inside to find a way to let it swim on a white background. Sometimes I will have an animal in mind and will be on the lookout for natural elements that look like feathers, scales, or fur. Other times I'll grab anything and everything I fancy, put it all into my foraging sack, and bring it home to play around with.

I now live in the city, with an unruly and beloved garden surrounding an urban cottage. My husband and I call our home The Burrow because it looks and feels like a hobbit hole. Much of my days are spent foraging for wildflowers in green areas of Seattle and playing with flowers on my kitchen table. Many of my Flora Forager pieces have come from my own garden, those of my dear friends, and my mother's luscious old-world roses that she still cares for, though they now tower over her head.

I am continually moved by the response my art has received from all corners of the world. Different cultures, ages, and classes have been connected through our love for nature. As Roald Dahl put it perfectly, I want to encourage everyone to "watch with glittering eyes the whole world around you" to find magic in unlikely places. Like finding a rainbow of berries on city streets, we can find diversity of color, precious details, new life, and breathtaking beauty in our natural world by being foragers of flowers.

To see more of my work, visit FloraForager.com or connect with me on Instagram @flora.forager.

—BRIDGET BETH COLLINS

A Peek at My Process

Here are the steps I took to make a frog prince!

Carnation (crown), eucalyptus (belly), gold dust dracaena (back), waxflower (feet), wintercreeper leaf (legs), wintercreeper pod (eyes)

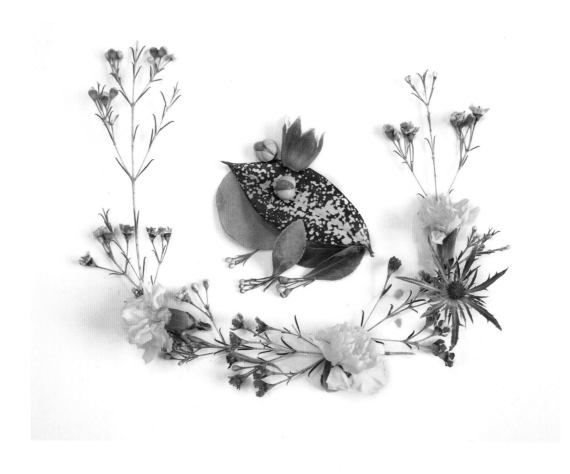

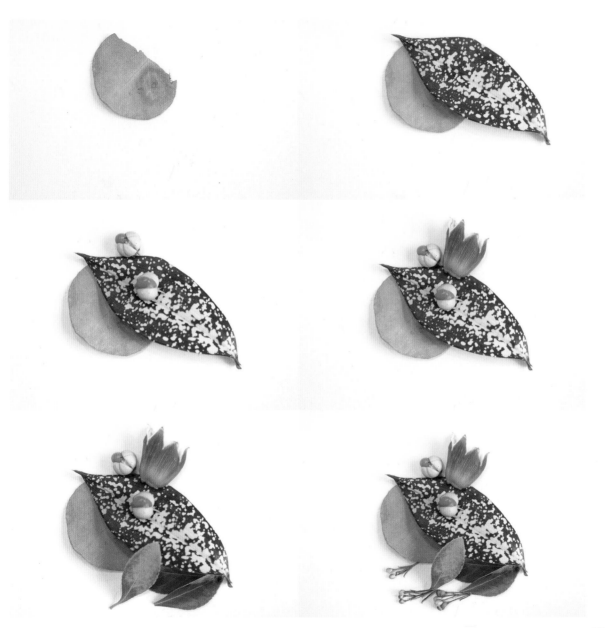

Index

A

Angel Fish, 144–145
Animals:
 Chameleon, 114–115
 Elephant, 118–119
 Giraffe, 118–119
 Lemur, 116–117
 Leopard, 112–113
 Lion, 114–115
 Panda, 118–119
 Red Panda, 114–115
 Rhinoceros, 120–121
 Seal, 120–121
 Sloth, 120–121
 Snails, 118–119
 Snake, 114–115
 T-rex, 120–121
Anne of Green Gables, 22–23
Audrey Hepburn: The Ingenue, 102–103
Autumn, 50–51

B

Balloons, 152–153
Bee, 136–137
Bird of Paradise, 130–131
Birds:
 Bird of Paradise, 130–131
 Cardinal, 130–131
 Cockatiel Swing, 128–129
 Cockatiel, 126–127
 Finches, 130–131
 Flamingo, 126–127
 Hawk, 126–127
 Ostrich, 130–131
 Parrot, 126–127
 Peacock, 124–125
Bits & Bobs:
 Balloons, 152–153
 Campfire, 156–157
 Carousel, 154–155
 Chamomile Tea, 154–155
 Copper Kettle, 156–157
 Cupcake, 152–153
 Hot Air Balloon, 154–155
 Ice Cream, 156–157
 Lemon Bicycle, 152–153
 Old Fashioned, 152–153
 Petal Rain, 154–155
 Popcorn, 156–157
Botticelli's *The Birth of Venus*, 74–75
Butterflies, 136–137
Butterfly, 136–137
Butterfly Meadow, 134–135

C

Campfire, 156–157
Cardinal, 130–131
Carousel, 154–155
Castle, 162–163
Caterpillar, 140–141
Chameleon, 114–115
Chamomile Tea, 154–155
Cockatiel, 126–127
Cockatiel Swing, 128–129

Constellations, 52–53
Copper Kettle, 156–157
Cupcake, 152–153

D

da Vinci's *Mona Lisa*, 78–79
Diana Ross: The Diva, 106–107
Dragon, 92–93
Dragonfly, 140–141

E

Eiffel Tower, 24–25
Elephant, 118–119

F

Fantasy:
 Dragon, 92–93
 Firebird, 82–83
 Gandalf, 88–89
 Garden Gnome, 88–89
 Hobbit Hole, 84–85
 Kraken, 90–91
 Loch Ness Monster, 88–89
 Mermaid, 86–87
 Unicorn, 88–89
Finches, 130–131
Firebird, 82–83
Fireflies, 138–139
Flamingo, 126–127
Flamingos, 16–17
Flora, 26–27
Flower Wars, 164–165
For My Boys:
 Castle, 162–163
 Flower Wars, 164–165

Harry Potter, 162–163
 Knight and Dragon, 160–161
 Pikachu, 162–163
 Tinker Bell, 162–163
Frida Kahlo: The Artist, 96–97

G

Gandalf, 88–89
Garden Gnome, 88–89
Geisha, 32–33
Giraffe, 118–119
Goldfish, 144–145
Grasshopper, 136–137
Green Gables, 20–21

H

Harry Potter, 162–163
Hawk, 126–127
Hobbit Hole, 84–85
Hokusai's *Under the Wave off Kanagawa*, 76–77
Home Sweet Home, 12–13
Hot Air Balloon, 154–155
Hot Air Balloons, 18–19

I

Ice Cream, 156–157
Iconic Women:
 Audrey Hepburn: The Ingenue, 102–103
 Diana Ross: The Diva, 106–107
 Frida Kahlo: The Artist, 96–97
 Lucille Ball: The Comedian, 104–105
 Marie Antoinette: The Queen, 98–99
 Marie Curie: The Scientist, 108–109
 Marilyn Monroe: The Sex Symbol, 100–101

Insects:
 Bee, 136–137
 Butterflies, 136–137
 Butterfly, 136–137
Butterfly Meadow, 134–135
 Caterpillar, 140–141
 Dragonfly, 140–141
 Fireflies, 138–139
 Grasshopper, 136–137
 Moth, 140–141
 Spider, 140–141

J

Jellyfish, 148–149

K

Kites, 34–35
Klimt's Mother and Child, 72–73
Knight and Dragon, 160–161
Koi, 30–31
Kraken, 90–91

L

Lemon Bicycle, 152–153
Lemur, 116–117
Leopard, 112–113
Lion, 114–115
Loch Ness Monster, 88–89
Lucille Ball: The Comedian, 104–105

M

Mandalas, 56–67
Mandalas:
 Mandalas, 56–67

Marie Antoinette: The Queen, 98–99
Marie Curie: The Scientist, 108–109
Marilyn Monroe: The Sex Symbol, 100–101
Master Copies:
 Botticelli's *The Birth of Venus*, 74–75
 da Vinci's *Mona Lisa*, 78–79
 Hokusai's *Under the Wave off Kanagawa*, 76–77
 Klimt's Mother and Child, 72–73
 van Gogh's *Starry Night*, 70–71
Memories & Muses:
 Anne of Green Gables, 22–23
 Autumn, 50–51
 Constellations, 52–53
 Eiffel Tower, 24–25
 Flamingos, 16–17
 Flora, 26–27
 Geisha, 32–33
 Green Gables, 20–21
 Home Sweet Home, 12–13
 Hot Air Balloons, 18–19
 Kites, 34–35
 Koi, 30–31
 Night, 24–25
 Plane, 16–17
 Pumpkin Carriage, 36–37
 Safari, 28–29
 Sailor's Valentine, 24–25
 Shooting Stars, 24–25
 Spring, 46–47
 Sugar Skull, 38–39
 Sugarplum Fairies, 40–43
 Summer, 48–49
 Surfers, 14–15
 Volcano, 16–17

Winter, 44–45
Woodland Birthday, 16–17
Mermaid, 86–87
Moth, 140–141

N
Night, 24–25

O
Old Fashioned, 152–153
Ostrich, 130–131

P
Panda, 118–119
Parrot, 126–127
Peacock, 124–125
Petal Rain, 154–155
Pikachu, 162–163
Plane, 16–17
Popcorn, 156–157
Pumpkin Carriage, 36–37

R
Red Panda, 114–115
Rhinoceros, 120–121

S
Safari, 28–29
Sailor's Valentine, 24–25
Sea Horse, 144–145
Sea Life:
 Angel Fish, 144–145
 Goldfish, 144–145
 Jellyfish, 148–149

 Sea Horse, 144–145
 Sea Turtles, 144–145
 Succulent Whales, 144, 146–147
Sea Turtles, 144–145
Seal, 120–121
Shooting Stars, 24–25
Sloth, 120–121
Snails, 118–119
Snake, 114–115
Spider, 140–141
Spring, 46–47
Succulent Whales, 144, 146–147
Sugar Skull, 38–39
Sugarplum Fairies, 40–43
Summer, 48–49
Surfers, 14–15

T
Tinker Bell, 162–163
T-rex, 120–121

U
Unicorn, 88–89

V
van Gogh's *Starry Night*, 70–71
Volcano, 16–17

W
Winter, 44–45
Woodland Birthday, 16–17

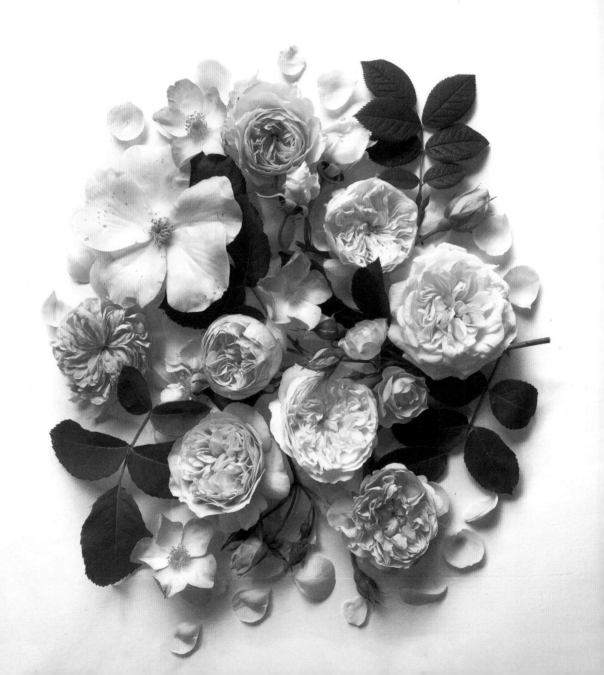

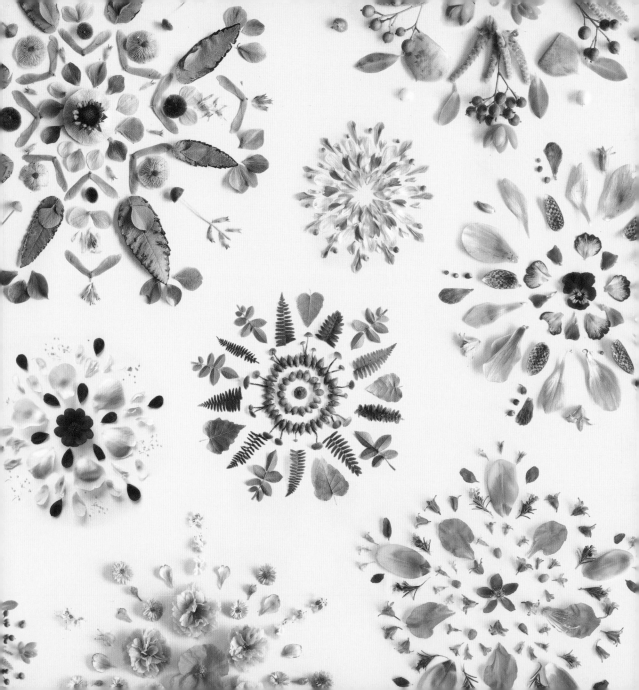